pretty little london

· TRIPS ·

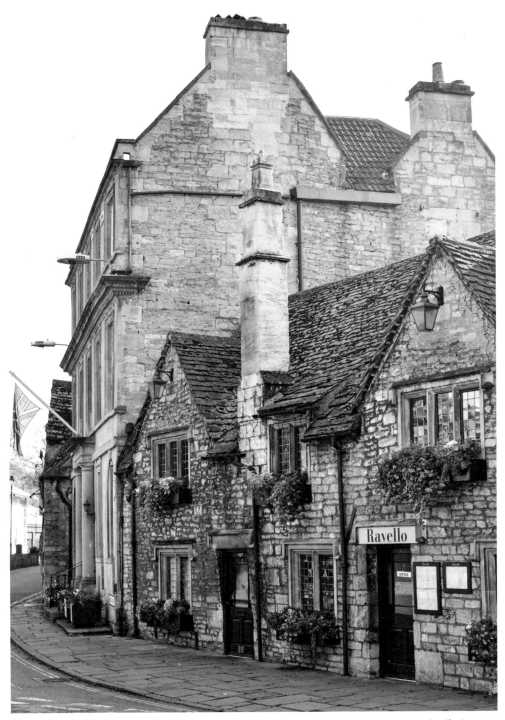

Bradford on avon

pretty Little london

· TRIPS ·

WEEKEND ESCAPES
FROM THE CITY

SARA SANTINI & ANDREA DI FILIPPO

FRANCES
LINCOLN

Contents

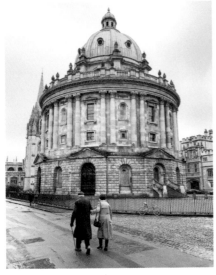

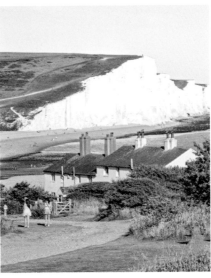

Countryside 132

Introduction

If there is one thing most Londoners have in common – apart from complaining about the weather – it's that they can't wait to get out of London. I mean, you love the city, but sometimes it can be so fast-paced that you literally need to slow down and take a breath, whether it's just for the day or for a weekend. We started going on day trips pretty soon after we arrived in London. We were having a lot of success with Pretty Little London and were looking for hidden spots and exploring new parts of the city, and this made us curious to see if England was all about London, or if there was more to it. Also, we knew other people were looking for inspiration for escapes from the city, but where to start? It was 2015, a time when Instagram still hadn't properly kicked off, so most of our inspiration came from word of mouth, and if there is one place that people always boasted about it was Brighton.

Beaverbrook

Ah, the beach, the seafood, the summer breeze… the disappointment! We were brought up in Italy, so we were naively expecting to be going to the Amalfi Coast of the UK. The water was freezing, the beach was packed with tents and barbecues in full swing, while there was no sign of La Dolce Vita. We went back to London defeated, thinking England might only be about London after all. The reality, as we found from our travels – and as you will find in this book – is that every single city and town, coastal location or countryside haunt has its own personality and you really need to get it and embrace it, to live it in full. Brighton, for example, is never going to be like Amalfi, or even like London, and when you think about it, that's the beauty of it.

So our trip to Brighton was definitely underwhelming and made us take a step back on exploring the UK, until we heard someone talk about a place we had never heard of before. The Cotswolds. We kept hearing the word fairy-tale when people referred to it, so we decided to give England another chance. And thank god we did. The feeling you get when you visit these villages for the first time is almost one of incredulity. Did we just step back in time? And the best part is that every single village is different and has its own charm. The Cotswolds has, since that first trip in 2016, become our happy place. And not only because it is picture perfect, but because it gives us that sense of tranquillity that sometimes is needed when you live in a big city. We have been over 20 times since and we almost feel like locals, as we know so many of the best restaurants, cafés, bakeries and hotels.

The Cotswolds opened a whole new world to us. It was worth leaving London for a day or two, now we were finally part of that group of Londoners that just couldn't wait to get out of the city and explore the UK. We started visiting more towns: we ventured to Rye in East Sussex to check out Mermaid Street, to Wells in Somerset for the oldest residential street in the UK – Vicars' Close – and to Bradford on Avon because – you know – it's just gorgeous. We started getting invites to review hotels and thought that if they were as beautiful as the towns were visiting, why not? And they were.

As you will realise while reading our book, some hotels in the countryside are actual destinations in themselves. You can literally check in on Friday evening and check out on Sunday without leaving the grounds; they are a full-on experience. They have incredible spas, vegetable gardens that you can't possibly imagine exist, acres and acres of land, some with deer and other wild animals roaming, and restaurants that more than compete, if not outdo, London's best eateries.

Visiting destination hotels, as we like to call them, helped us further expand our horizons. It got us even more into design, art and cuisine, and we've indirectly learned so much about England's history too. Going to The Newt inspired us to visit more of Somerset, staying at The Beaverbrook to explore the stunning Surrey Hills, and The Pig on the Beach to give the British coast and its beaches. We started to appreciate the English coast and it is now one of our favourite destinations to travel to and discover. We appreciate the beauty of the landscapes and the traditions and culture of these locales, which are full of history.

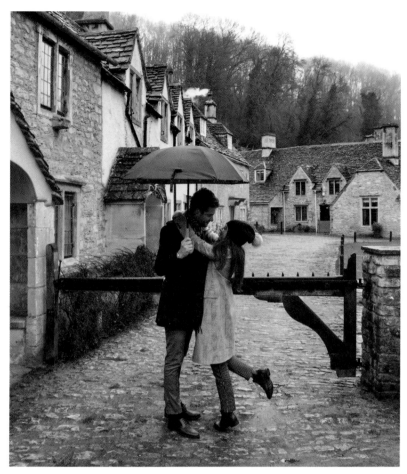

We fell in love with the Cotswolds and it ignited our passion for exploring the UK.

We did end up giving Brighton another chance too, and going back was a completely different experience. We didn't go to the beach this time, but explored the cobbled streets, the quirky shops and the artistic side of the city. We have been back many times since.

We put this book together to inspire you to explore more of the UK, helping you find the best things to do if you fancy escaping to a new location or if you have been before and would like to try new things. For each city you could write an entire book, so we have chosen a theme that, for us, is the best reason to visit and represents the atmosphere of each place, so that you can make the most of your trip. In some cases, we tried to go in the opposite direction and looked for something different to explore, rather than the obvious. So, don't expect a Harry Potter guide to Edinburgh this time! We hope you enjoy it!

University Arms Hotel, Cambridge

UK Travel Tips

Before showcasing the locations, we thought we would share our best tips for travelling around the UK, to give you the best chance of a seamless journey.

Most of the destinations in our book are within a three-hour reach of London, with a few exceptions such as Cornwall and Edinburgh. For each entry, we have included the best way to get to the location from London, but these are only suggestions; there are many different methods of transport and you can obviously find your own way there! Also, this doesn't mean you have to be in the capital to be able to visit these places. This is a book that anyone can benefit from as it offers general travel inspiration in the UK.

Most cities can be reached by train and it usually takes less time compared to going by car. It's also arguably less expensive with fuel costs such as they are, and more environmentally friendly. There are railcards available that cost as little as £30 a year, that could save you a third on each journey – meaning that, even if you use them a few times a year, you will make your money back. As for smaller, out-of-the-way towns and destination hotels, most of the time you will need to go by car. If you don't own a car, we would recommend using apps like Getaround or Virtuo, which either deliver a vehicle to your home or allow you to pick it up in Central London. Or you could rent a car from the closest airport to the destination, which will avoid you getting stuck in London traffic. Check parking in advance as it will save you time once you arrive, especially for Cornwall during the summer time, which is extremely busy.

In terms of packing, unless you are travelling to a city, we would always recommend bringing boots or wellies, as we're in the UK and the chances of it raining and getting muddy are pretty high. Also pack sunscreen, if you don't want unexpected sunburn. Believe us, we've learned the hard way in both cases. In terms of the dress code for the countryside, it may be quite relaxed, but always pack something a little fancier, just in case you want to dress up for restaurants or for afternoon tea.

If you have a restaurant in mind that is a must-visit destination, always book it in advance: we have ended up disappointed so many times! It's especially important when travelling on a weekend or if the area is remote and there are not that many options, such as in Mersea Island.

One of the best tips we can give is to buy National Trust membership, which gains you access to the most beautiful parks, gardens and estates in the UK. The price is around £75 per person for a whole year. Check out the website or app for details and the latest prices.

Photography Tips

In our first book, *Pretty Little London: A Seasonal Guide to the City's Most Instagrammable Places*, we gave you some Instagram tips and put together a beginner's photography and editing guide to help you get started. In this book, we will give you further tips to help you capture the perfect shot.

Lighting

Everything in photography and videography is about light. Think of it this way: if you take a picture without any light, what do you get? Exactly, a black photo. That is how important light is, so getting this aspect right when you are taking pictures usually makes all the difference in the world. The absolute best time of the day to shoot – and we're sure most of you already know this – is during the golden hour. Often referred to as the magic hour, this is the 30 minutes before sunrise and the 30 minutes after sunset. In this period, the shadows are less dark and almost disappear and the light is less harsh, with the warm light of the sun enhancing all the colours around you and making them consistent. We know that shooting during the golden hour isn't always possible, but this doesn't mean you can't shoot well at different times of the day. The best thing is to get your light as consistent as possible: so on a sunny day, either shoot your subject completely in the sun or completely in the shade and you'll avoid those shadows that are so hard to edit. Gloomy day? Great. The clouds will do the work for you as they filter the sunlight and make it nice and consistent.

Architecture

Do you ever see photos of the exact same building taken from the same distance and while one looks perfect, the other one looks all over the place? That is probably because one is symmetrical and the other one isn't. When you take your photo, make sure that the main subject is at the centre of the photo and that there is equal space to either side. This will make the photo clean, proportionate and balanced – meaning the photo will look nice and tidy. Also, make sure to shoot with your camera straight without tilting it. If you feel the urge to tilt, you are probably too close to the subject. Most of the time, taking a few steps back is an easy fix. If the building you are trying to shoot is too big and you are too close, maybe try to focus in on a small detail and give your own unique perspective rather than trying to capture the entire building.

Details

They say the devil is in the detail, and we have to say that we definitely agree with that. Sometimes photos can look a bit static and soulless, in the sense that even if you're shooting a beautiful street or shopfront, if it's empty it might look a bit boring. What we like to do is wait for someone interesting to walk by, who either matches the vibe of the place we are shooting or is the complete opposite. If you are shooting on the coast maybe wait for a fisherman; if you are shooting in Oxford or Cambridge look for an

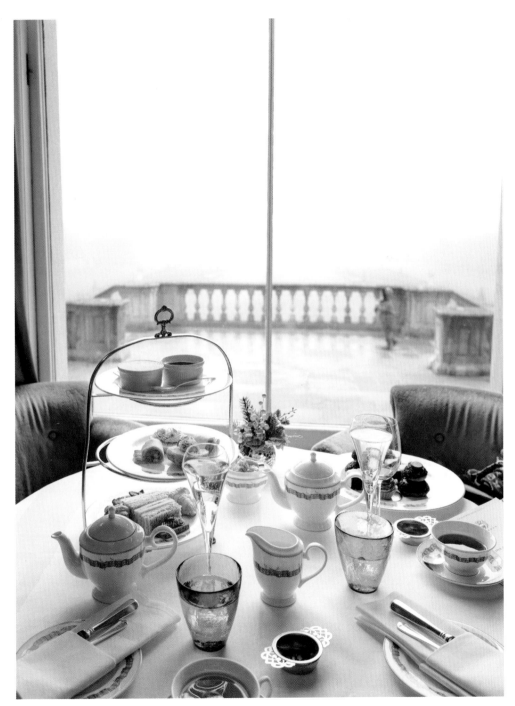

Cliveden House

Camber Sands

academic or an eccentric student; or if you are in the Cotswolds, look for someone taking their particularly photogenic dog for a walk. You get the drill. The important thing most of the time is not to have empty spaces in your shot. You can even ask a friend to casually stride by if you have to! The same thing applies to food photography, which people go crazy for nowadays. Make sure that there are no empty spaces in your photo, and if there are, you can always add a human touch, which also adds a bit of motion to your picture. Maybe pour some coffee, pull some spaghetti up with your fork, reach in to try a try a scone or do a 'cheers' with your champagne glasses. We'll leave it to you.

Apps

Photo editing is almost as important as taking the actual shot, so be sure to use the apps that are most suited for your style of photography. We shoot mainly with a Leica Q2 and we edit on an iPhone, with Adobe Lightroom being our preferred app (there is a little guide in our first book; see pages 14–15) as it's pretty intuitive and preserves the image quality, plus you can use most of its features on the free version. We also use Enlight to overlap photos, as it has a great mixer option, meaning that if there is a photo you like but you notice a detail you would like to add from another photo with a similar angle, you can do it by overlapping them. Or if there is a small

detail you would like to remove, like a bin bag or a street cone, we use an app called Retouch which will literally remove it in seconds. For filters and pre-sets, Snapseed and VSCO are great options, and we sometimes use them when we want a quick edit for Instagram Stories. If you are looking to plan your feed and make it colour-coded, UNUM and Unfold are your best options.

Video

Video content has become extremely popular in the past few years thanks to Reels on Instagram and TikTok. We personally love video content as it's very engaging and catchy, to the point that a big part of our content on social media is now video. So, what makes a good video? How do you put something together that people will be interested in? The key is to get the viewer hooked in the first two seconds so that they continue to watch your video. You could start with some copy like 'The ten best things to do in Cornwall' or 'You won't believe what we saw in Wells' – so that the viewer doesn't swipe away and continues watching. Once you have caught their attention, then you have to deliver a good video. Many principles of photography also apply to videography, so get your angles and lighting right and capture the small details. With video the human touch is even more important. In terms of apps, we edit most of our content on Videoleap, where you can add multiple videos and music, adjust the colours, crop and even set the transitions between videos based on the music's tempo. Another useful app is Tone, where you have all of the colour adjustment options of Videoleap, plus you can fine tune specific colours. It has some fantastic filters that we sometimes use for Stories.

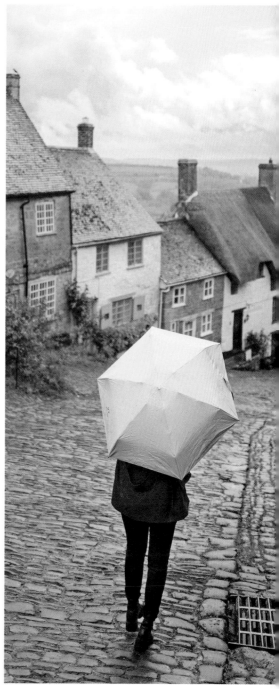

Shaftesbury

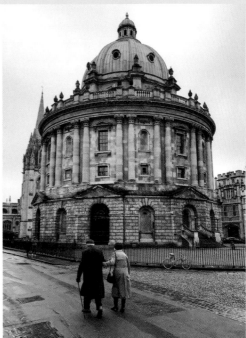
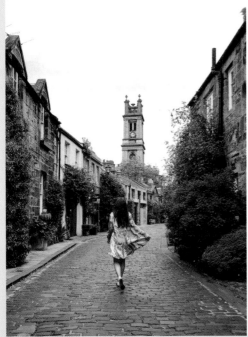

CITY
&
TOWN

CHURCH BELLS. *Cathedral towns.*
New discoveries. Up north, at the
seaside, in the country. Universities.
So much history. WINDSOR. Hello,
Your Majesty! *What's your favourite?*
Big cities, small towns. *Have you been?*
Hipster vibes, classy sides. BRISTOL.
BATH. So close, so far apart. Roman
Baths. Graffiti art. Day trip. *Hop on the
train.* So much to see. Staying the night.

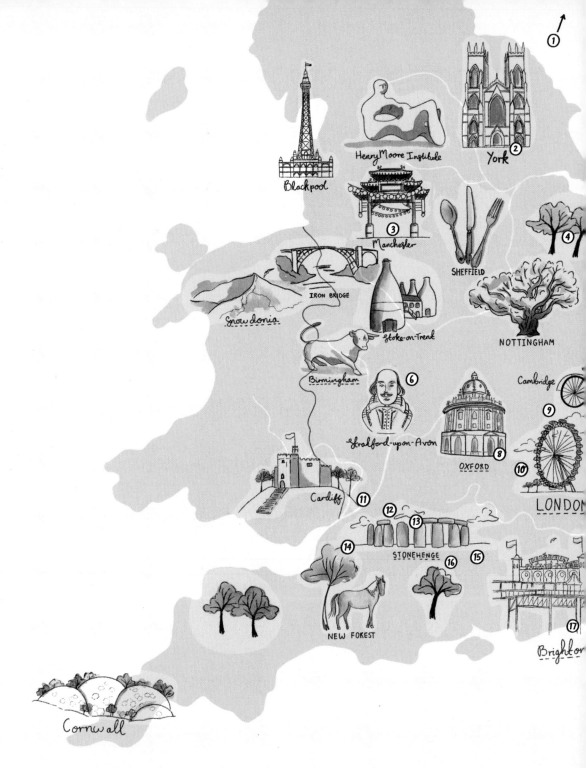

Norwich ⑤

southwold

DOVER

Edinburgh

A VIBRANT CAPITAL CITY

 5h from London King's Cross 🕐 48 hours

Edinburgh is definitely one of the most fascinating cities to visit in the UK, no doubt about that. Steeped in history and culture, Harry Potter fans love it for the connection to the wizarding world – JK Rowling penned the first books here, sitting in a café, and the sights of this vibrant town are said to have inspired the famous books.

People from all over the world are enchanted by the beautifully rugged Edinburgh Castle, the quiet elegance of Holyrood, the colourful curve of Victoria Street and the medieval narrow streets of the Old Town. Once you have seen all of this, there is even more to explore in Scotland's glorious capital.

One thing Edinburgh is not short of is gorgeous hotels, The Balmoral and Waldorf Astoria among the most well-known. Much more of a hidden gem, and one of our own favourites, is Cheval The Edinburgh Grand, situated in the New Town, in St Andrew Square. This hotel is divided into luxurious serviced apartments, in what once was a landmark, The National Bank of Scotland. It's the perfect location from which to explore the city. From the moment you step inside, you'll feel welcomed and pampered and we just loved this feeling of it being a home away from home. The Register Club, on its fourth floor, is the perfect spot for a cocktail or afternoon tea – you can

even partake of haggis! – and the plush sofas and elegant surroundings will tempt you into ordering a glass of champagne. Of course, if we're talking afternoon tea, the sumptuous Palm Court at The Balmoral is next-level luxury, and sitting under the impressive Venetian chandeliers while listening to live classical music is just idyllic. Plus, they have 88 loose leaf teas to choose from, so you are really spoilt for choice.

If you are in the mood for fine dining, Edinburgh is a foodie's delight. We like The Pompadour, Dean Banks' restaurant at the Waldorf Astoria, which has incredible views over the castle and really special tasting menus – the dining room is, quite frankly, the most beautiful in town. A lovely alternative for a fraction of the price is the playful Six by Nico, with its six-course tasting menu, with optional wine pairing, that changes every six weeks, and doesn't break the bank.

For more intimate experiences, Condita, on the southside of the city, has only six tables and prepares beautiful plates for those that booked, so don't hope for a walk in. Another tiny but mighty restaurant is The Little Chartroom, at the top of Leith Walk, with its relaxed but refined vibe, just like its menu.

If you want a view – and Edinburgh is full of them – head to the 1820 Rooftop Bar, at Johnnie

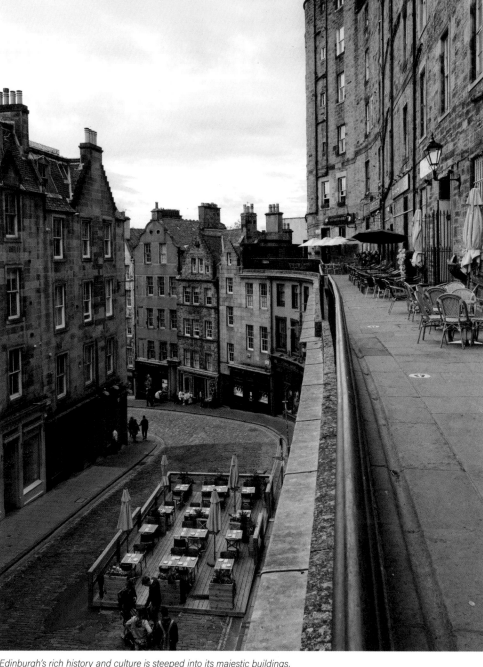

Edinburgh's rich history and culture is steeped into its majestic buildings.

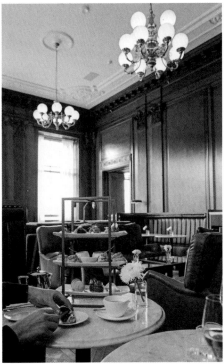

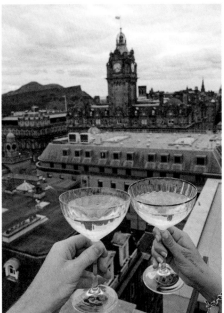

Walker on Princes Street, for crafted cocktails and epic views of the castle and historic Old Town. The museum here is such a good, immersive experience, too, even if you aren't into whisky.

In terms of what to see, excluding the castle, of course, we definitely would suggest a wander around the National Museum of Scotland. The main hall is beautiful and makes for a great photo opportunity too. Talking of photos, head to Circus Lane, in the Stockbridge area, behind St Stephen Street. This picturesque residential lane – with its terraced mews and hanging baskets of flowers – will make you want to snap a few pictures!

From here, we suggest continuing towards the leafy Dean Village, also home to the impressive Scottish National Gallery of Modern Art. But if you're happy to wander, this is a tranquil, beautiful place and you'll feel as they you're stepping back in time, walking past the old mills and the canals.

For a cute photo, head back to the Old Town to the Royal Mile and go through Chessels Court where you'll find a beautiful ivy heart on the wall of one of the impressive eighteenth-century mansions there.

+ INSIDER TIP

For lovely views over the city, walk up to Carlton Hill. It takes less than 20 minutes and if you go at sunset, you'll (hopefully) be rewarded with the beautiful colours of the omniscient sky. Have lunch at The Lookout (Thursday–Sunday) for earthy and simple seasonal plates, overlooking Edinburgh's majestic skyline.

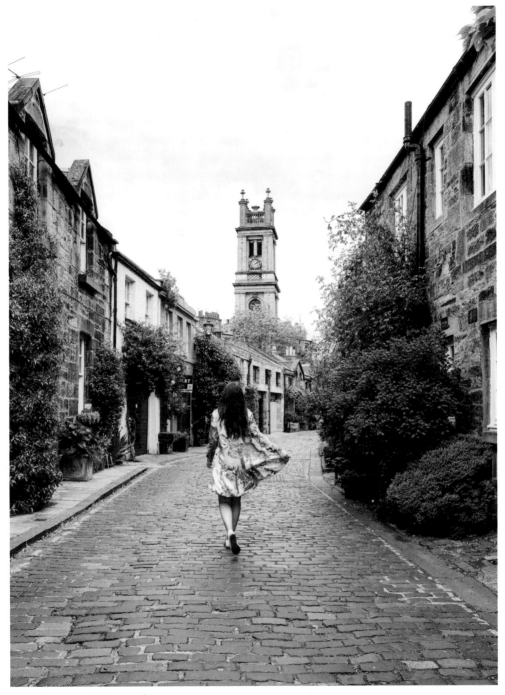

Pretty Circus Lane is picture-perfect.

York

A VERY SPOOKY CITY

 2h from London King's Cross ⊕ 48 hours

If you have been to York before, you will probably have felt a certain sense of spookiness while roaming through its streets. That is because this medieval city is allegedly home to 140 ghosts and has recorded more than 500 hauntings, making it the most haunted city in Europe and probably in the world! Historic York has a dark and violent past and every little alleyway, pub and building seems to be stalked by spirits. There's even a Murder Mystery Trail! So, what are the spookiest spots to visit in York?

The most talked-about building and a must-visit is the Treasurer's House, where in 1953 a man named Harry Martindale was installing a new boiler in the basement of the house. All of a sudden, he heard a loud horn and saw a legion of dishevelled Roman soldiers on their horses, who were riding through a recently excavated area that used to be an old Roman road called Via Decumana. He ran upstairs to tell the curator, who said, 'By the look of you, you've seen the Romans!' You can visit the cellars of the Treasurer's House yourself to look for the Roman legionnaires, and also be sure to check out the gardens while you are there as they are stunning.

Just behind the Treasurer's House is York Minster, the oldest Gothic castle in northern Europe and the tallest building in York, giving it the best view over the city. Where there is history, there are of course a lot of ghosts! Legend says that in the 1820s, two tourists were approached by a sailor who whispered something in one of the women's ears. It turned out that the woman had an agreement with her brother whereby the sibling that died first would come back to confirm that there was an afterlife. This was him, honouring their pact. There also seems to be a deceased parishioner who likes to attend services. How spooky!

The most haunted city in the world obviously lays claim to some of the most ghost-infested pubs, many of which claim to be the spookiest of them all. Ye Olde Starre Inne at Stonegate is thought to be the oldest pub in York and has been licensed since 1644. Used as a hospital and mortuary during the Civil War, it's no surprise that guests claim to see the ghosts of soldiers long past, along with a couple of black cats! The Golden Fleece, on the Pavement, is said to host around 15 ghosts, the most notorious being one

Opposite: Selling handmade ghosts, The York Ghost Merchants is the spookiest shop on The Shambles

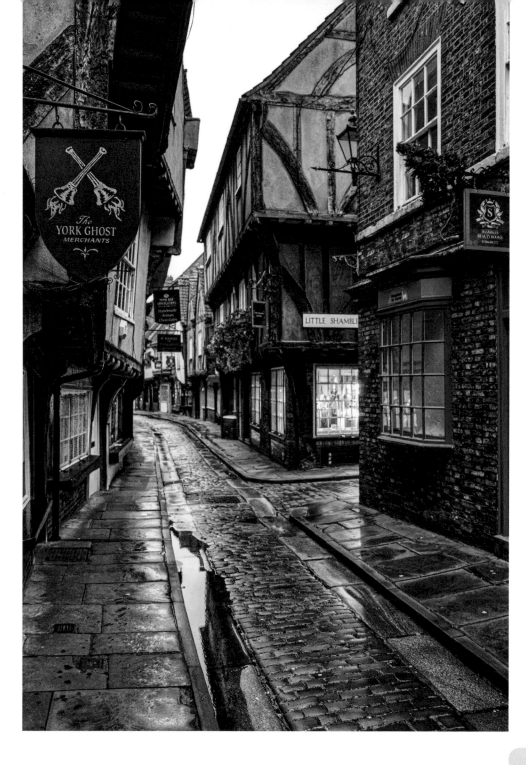

Lady Alice Peckitt, wife of a former Lord Mayor of York, who is said to roam the endless corridors and staircases, her footsteps often heard in the morning. The Snickleway Inn, which dates back to the fifteenth century, is another place that claims to be the most haunted in the city, with an undefined presence in the cellar and an old man seen walking through the back wall. Ghosts apart, we can confirm that these three pubs are great spots for some good food and a pint too!

A visit to York can't fail to include a stroll along its most beautiful street, The Shambles. This cobbled street has been there since medieval times, and even though none of the original shopfronts have survived, you will find lots of quirky and unique boutiques here. If you look at number 6, you will probably see a long queue leading from The York Ghost Merchants, a unique shop selling handmade limited-edition ghosts! The perfect souvenir.

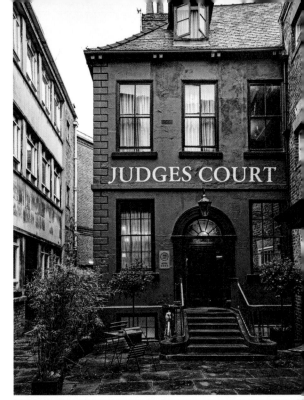

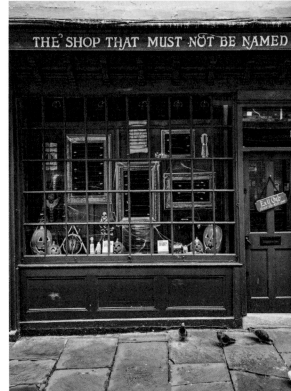

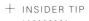

+ INSIDER TIP

If you go for a spooky weekend to York, there is no better place to stay than The Judges Court, a four-storey Georgian grade II-listed building that once provided judges' lodgings and today literally looks like a haunted house. This hotel is hidden in a secret courtyard, right in the city centre, and could definitely be infested with ghosts!

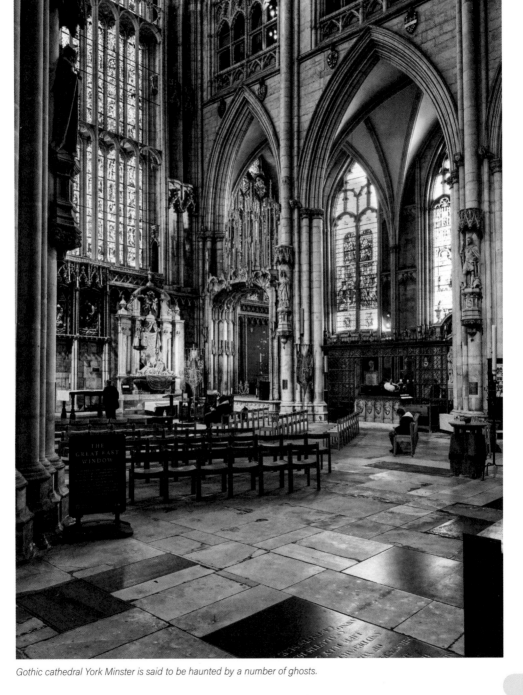

Gothic cathedral York Minster is said to be haunted by a number of ghosts.

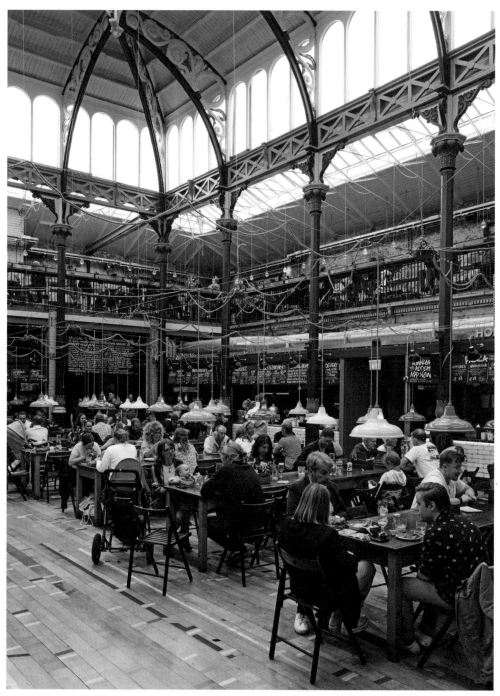

Mackie Mayor, located in a striking grade II-listed building, houses stalls serving food from across the globe.

Manchester

A VIBRANT HIPSTER CITY

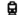 2h from London Euston ⊙ 48 hours

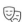

Manchester is really up there when we think of cool cities to visit, and over the years it has gained quite the hipster reputation. Its industrial past has made it possible for many cool sites, such as warehouses, old factories and brick buildings, to have a new lease of life as restaurants, hotels and hip bars, while its cultural and creative diversity definitely reflects in the different neighbourhoods.

The once run-down and industrialised Northern Quarter is probably the hipster neighbourhood par excellence. After an intensive glow-up in the 1990s, this 'hood' is now crammed with interesting restaurants and bars that turn into clubs at night, independent coffee shops and trendy boutiques. Enjoy the vibrant atmosphere and walk around the bustling narrow streets and maze-like alleyways. If you think it reminds you of somewhere else, the architecture is so similar to New York that it has been used as a location stand-in for many NY-based TV shows and movies, including the remake of *Alfie* and *Captain America*.

Don't forget to pop by Afflecks, a warehouse building turned indoor market, with costumiers for the likes of Lady Gaga. Roam around the independent and eclectic stores and find everything from alternative wear to vintage clothes, tattoo studios and fetish stores. It's definitely an experience to tick off your Manchester list! If you are searching for great coffee, we suggest the Iceland-inspired Takk or the industrial-chic Foundation Coffee House. For lunch, stop by Mackie Mayor, an impressive food market set in a converted 1858 meat market and now Grade II-listed building. The hall and glass roof are beautiful and you'll find everything from great sourdough pizza at Honest Crust, to insanely good day-caught fish at Fin Fish Bar and Hake Bao at the Baohouse. An absolute must in the area is the speakeasy style bar The Washhouse, which literally takes you through a launderette entrance to a dimly lit bar serving cocktails with no shortage of wow factors.

Another great nightlife spot and area to see is Deansgate, a mile-stretch of road that connects pretty much every area of the city. It's a great mix of old and new and very strong on its industrial history. Head to Deansgate Locks to see bars and pubs located under railway arches – Speak in Code serves the best cocktails.

Diverse and colourful, Chinatown, the second largest in the UK, is up there among the city's most vibrant neighbourhoods. Enter this lively community through a huge pagoda-style gate and get lost in the many Chinese and oriental restaurants and bakeries. We love Wong Wong Bakery, on Princes Street, for traditional buns and

CITY & TOWN

bubble teas and the neighbouring Yang Sing for dim sum.

For a more laidback vibe, go to the south-western part of Manchester to reach bohemian Chorlton, once home to Morrissey, the Stone Roses and even the Bee Gees. Full of independent shops and bars, organic delis and sustainable lifestyle businesses, start at Beech Road and head down the pretty street to find many cute shops and coffee places. Head to The Laundrette for fun cocktails and brunch.

Also check out the red-brick warehouses and Italian-influenced Ancoats district for great food and drink. Have a beer at Cutting Room Square or Blossom Street Social. Sandwiches are great at Companio Bakery, where sourdough is a speciality – if you can get through the door as the queues are long. And for Italian food, head to Rudy's Pizza Napoletana or Sugo Pasta Kitchen. Your coffee spot must be Ancoats Coffee Co, with its great drinks and commitment to sustainability.

For long canal-side strolls, head to the nearby New Islington area and enjoy walking past the mix of modern apartments and casual dining spots. Pollen Bakery makes the best breakfast buns, with outside seating on the picturesque Islington Marina.

For your stay, we would recommend the serviced apartment-style Native, located conveniently between the Northern Quarter, the Gay Village and New Islington. It is nestled in a converted Grade ll-listed warehouse and has a lounge, bar, restaurant, outdoor terrace and even a cinema.

+ INSIDER TIP
〰〰〰〰

Discover a gem at Manchester Central Library. The architecture of the building is so beautiful and, after a £50 million refurbishment project, the library houses a media lounge and a music library too.

Lincoln

A HIDDEN GEM OF A CITY

🚆 2h from London
King's Cross 🕐 12 hours

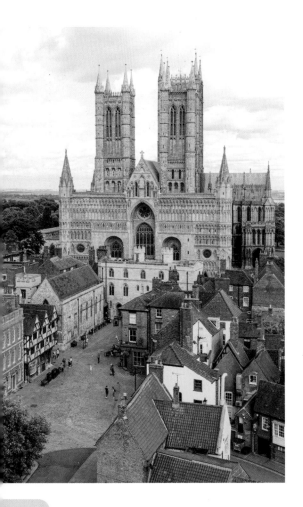

Lincoln is definitely one of England's best-kept secrets. Situated in the East Midlands, it's probably not the first city that comes to mind when you are planning a day trip from London, but we can guarantee that it will blow your mind. This cathedral city has 2,000 years of history and is packed with cobbled streets, quirky shops, cute tea rooms and historical buildings, all with a real village feel. It even has Roman remains in the city centre, as Lincoln was one of the major Roman cities in Britain.

After arriving at Lincoln Station, we would suggest a quick stop at Coffee Aroma, an independent voted as one of the best coffee houses in the UK. Once you've gotten your fix, it's time to head up Steep Hill, a stunning, narrow cobbled street full of independent and quirky shops and eateries, which will make you feel as if you are walking back in time. As the name suggests, the hill is quite steep, so be ready for a nice exercise session!

The reward of arriving at the top of the hill – apart from a lovely walk – is reaching the beautiful Lincoln Cathedral. This dates back to the eleventh century and is one of the largest in Europe and the second-largest Gothic cathedral in the UK after York Minster. And if that isn't a great reason to go in and explore the interior, then we don't know what is. Afterwards, we would definitely recommend heading to nearby Lincoln Castle.

+ INSIDER TIP
〰〰〰〰〰

If you have spent the whole day on Steep Hill and in the Cathedral Quarter and want a change of scenery, Brayford Waterfront also features lots of restaurants and picturesque views. Our favourite spot is The Electric Bar, serving British cuisine from a rooftop location, with an incredible view of the cathedral, especially at night!

The castle is probably the best attraction in the city. It was built on the site of a Roman fort and used by the Normans, in 1068, as a fortress to keep people out. Ironically, it then became a prison in 1199, this time making sure that people remained in! It is interestingly designed with a so-called 'separate system', which means that inmates were kept apart from each other so that they weren't corrupted by the influence of their fellow prisoners. The best part? The Victorian prison is now fully open to visitors, and you can even visit one of the spookiest chapels you will ever see, which features tiny one-person compartments that ensured prisoners couldn't speak to each other and could only see the pulpit. It is also home to one of the four remaining copies of the Magna Carta, which dates back to 1215.

Lincoln isn't short of great eateries and if you want to check out the oldest pub in town, head to Adam and Eve Tavern. It's just by the cathedral and you will deserve a pint after ascending Steep Hill. Browns Pie Shop is also a great choice for a pit stop, while if you are looking for the best tea in town, head to Bunty's Tea Room, a family-run vintage place set in a Grade II-listed building, full of quirky and retro objects and serving homemade scones and cakes.

For dinner, we would head to The Jews House, set over two floors in one of the oldest stone houses in Britain. The name refers to the woman who once owned it in the thirteenth century, who was executed (the Jews were expelled from Britain in 1290). The Jews House serves delicious seasonal food. Perfect for a romantic evening.

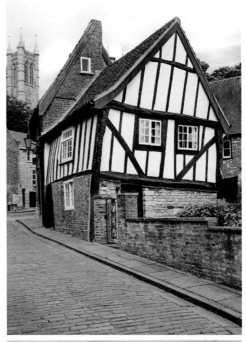

Norwich

GET LOST IN ITS COBBLED STREETS

🚊 2h from London Liverpool Street 🕐 12 hours

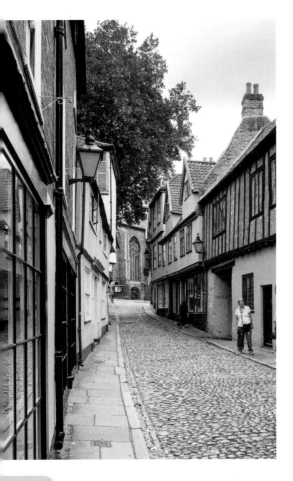

Norwich, in East Anglia, is definitely one of the nicest day trips you can take when you want to escape the hectic streets of London. Norwich is one of the best-preserved medieval cities in England and it's jampacked with charm, cobbled streets, narrow alleyways, independent shops and ancient buildings.

For your first visit to Norwich, we would recommend just getting lost in its streets, maybe popping into whichever café or shop catches your eye. The Lanes are the perfect place to start as they have incredible history and beautiful architecture. Here there are shops that have been operating for hundreds of years, antiques, churches converted into music venues and ancient courtyards. They are the beating heart of the city and embrace creative minds, which means that these streets aren't only about what's old, but are full of independent and quirky restaurants and cafés. We would recommend stopping at The Bicycle Shop for your coffee fix before continuing your wander as it's just too beautiful! The Lanes might be the most charming part of Norwich, but Elm Hill wins the trophy for the prettiest. It is literally a photographer's dream, with buildings dating back to the Tudor period and some unique shops, like The Bear Shop, which has the biggest selection of teddy bears in

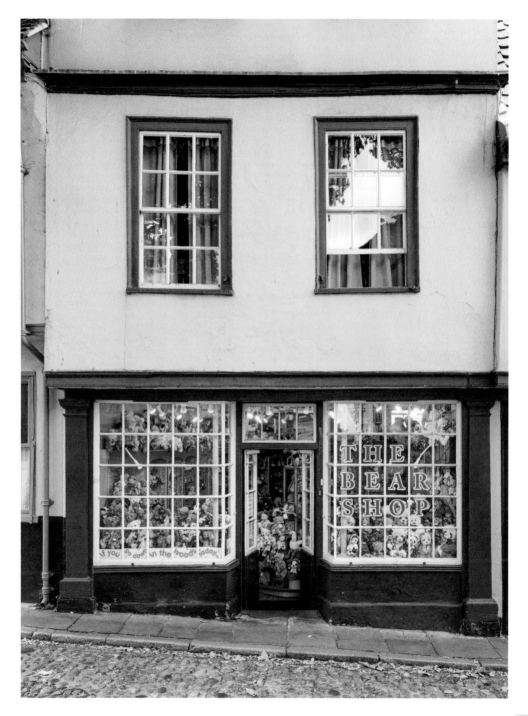

England. A trip to Elm Hill is not complete without a stop at The Briton Arms, as it's the only building that survived the big fire of 1507 in the city.

Another must-visit street is Tombland, one of the oldest parts of the city. If, like us, you are a sucker for bookshops you need to pop into the Tombland Bookshop, located in a fifteenth-century timber building, opposite the cathedral.

If you are feeling hungry after all of this, we don't blame you. There are lots of great restaurants, but we would recommend eating some street food at the famous market. There are over 200 stalls, making it the biggest permanent open-air covered market in Europe, and you can find literally anything, from clothes and plants to antiques and books. On a hot summer day, you will also be able to get ice cream!

Like any self-respecting medieval city, Norwich has two beautiful cathedrals, the Norwich Cathedral and the St John Baptist Cathedral and the Narthex. If you don't have much time, we would suggest you only visit Norwich Cathedral as it's the most famous and beautiful of the two. It has over 900 years of history and is considered one of the finest complete Romanesque cathedrals in Europe. If you are lucky enough, you will be able to visit when one of the many exhibitions is running.

If you have time for one last stop, head to The Royal Arcade. This has to be one of the most beautiful covered shopping streets in England and has been there since 1899.

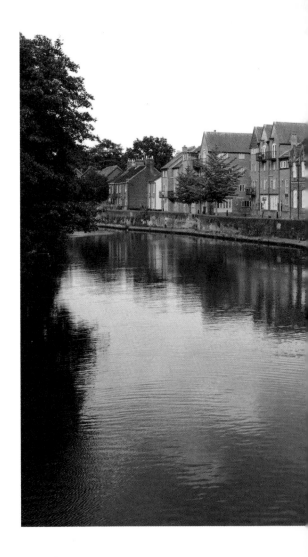

+ INSIDER TIP
〜〜〜〜〜

If you want to finish your day trip in style, head to the train station with a picturesque walk along the city's River Wensum. You can start near Elm Hill and it will take you around 30 minutes to get there, that is if you don't stop every 5 minutes, like we did, to take photos!

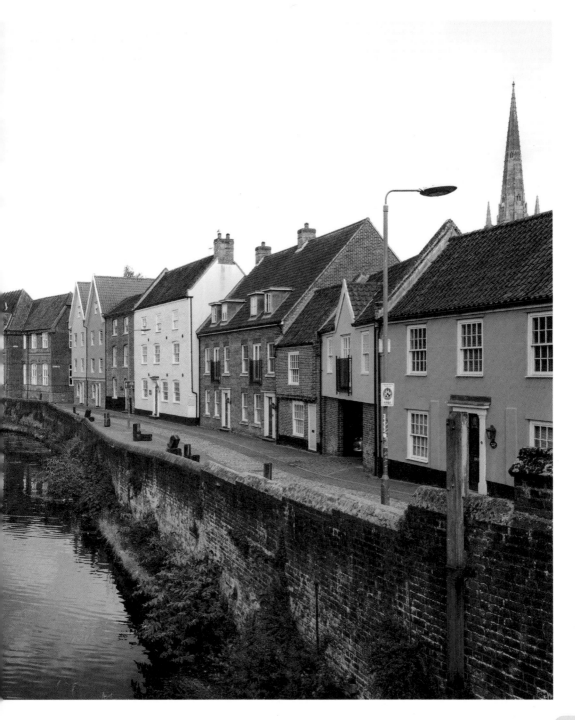

Stratford-Upon-Avon

A JOURNEY THROUGH THE BARD'S LIFE

 2h London Marylebone ⏱ 24 hours

Whenever you hear the name Stratford-Upon-Avon, there is only one thing that comes to mind: William Shakespeare. This historic market town is famous as the birthplace of the most well-known English poet and playwright of all time. It can easily come across as a tourist trap as most venues have some sort of reference to the poet – and this small market town sees over six million tourists per year.

The first stop during your day trip to Stratford-Upon-Avon must be Shakespeare's birthplace in Henley Street. Here, the bard lived the first 24 years of his life and every room provides insight into Shakespeare's early life. The house, the largest in the street, is pretty fascinating, and you really will be following in his footsteps – the house floors haven't been replaced! After visiting the bedrooms, kitchen and pub area (Shakespeare's brother leased part of the house out as an inn, after their parents' death). You will even see an original glass window signed by author Charles Dickens. Then head to the garden where actors perform some of the bard's best sonnets, and they even take requests!

Visit Henley Street to see the house where Shakespeare grew up.

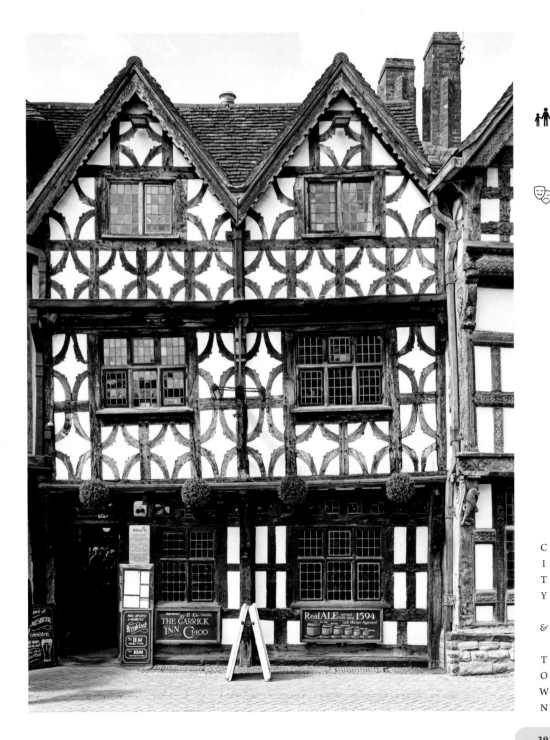

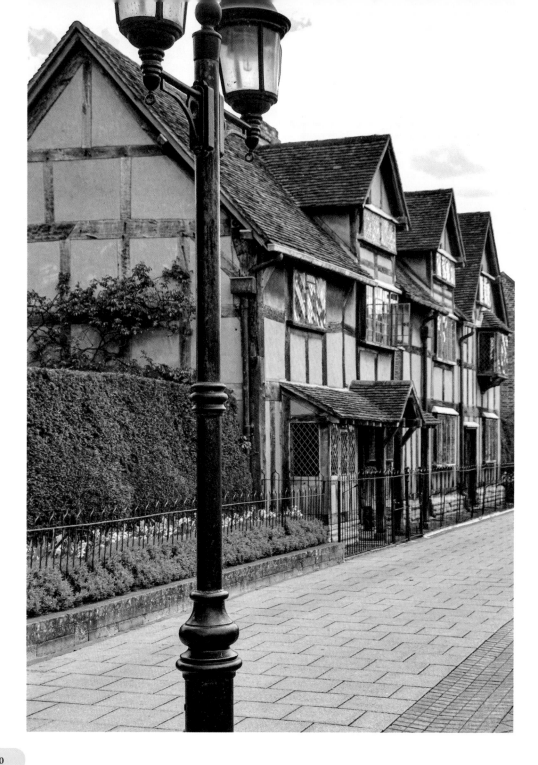

From here, head to <u>Shakespeare's New Place</u>. The bard purchased a house on this site after he made a fortune in London and lived there for 19 years, but sadly the building was knocked down and rebuilt by his daughter, Susanna Hall, and her husband John, who considered the grand Tudor home old fashioned. The home has been rebuilt many times over the years, but today it's a modern representation of the poet's life, with beautiful, idyllic gardens full of Shakespearean references, such as artistic interpretations of his plays and a floor paved with quotes from his sonnets.

One of the most interesting buildings to visit is <u>Shakespeare's schoolhouse</u>, which used to be an all-boys school! Here you can visit the very room where Shakespeare wrote his first works, with a 'Master' available to answer all your questions.

Want to pay respect to the poet's grave? Head to the <u>Holy Trinity Church</u>, a landmark with stunning architecture and the oldest building in town, where Shakespeare was baptised and was a regular worshipper.

There are many interesting things to do in the town centre, but we would definitely recommend leaving some time to visit <u>Anne Hathaway's Cottage</u>, which is approximately a 45-minute walk from the centre or a 5-minute drive. This is probably our favourite place to visit when we head to Stratford-Upon-Avon, as Shakespeare's wife-to-be's house looks mostly as it was 500 years ago and includes acres of beautiful cottage gardens, with a sculpture trail inspired by the poet's plays. The interiors are also stunning and uncover stories of the Hathaway family, who lived there for 13 generations!

A visit to Stratford-Upon-Avon must end with a play at one of the <u>three theatres</u> owned by the Royal Shakespeare Company, right? If you are there during the summer, also check to see if they are holding any performances outdoors.

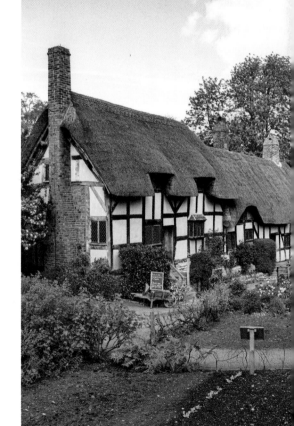

+ INSIDER TIP
~~~~~~~~

*If you are planning to visit more than one museum, it's probably best to get yourself or your family a Shakespeare's Story Ticket, as it will save you quite a bit of money. If not, your day could end up being quite expensive!*

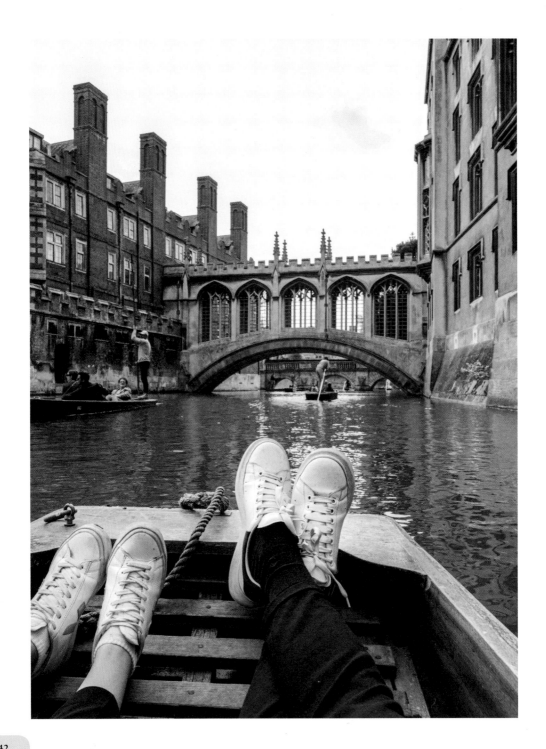

# Cambridge

## GET CULTURED IN CAMBRIDGE

 45m from London King's Cross  ⏲ 36 hours

Cambridge must be one of our favourite spontaneous day trips, being so well-connected to London and only a little over a 30-minute train ride away. And, even though relatively small, Cambridge has a lot to enjoy. There are many campuses to visit, and allow time to spend walking around the city – so, if you want to extend your visit, make it a weekend away instead. You'll be glad to have some extra time and have the city to yourself, and maybe even pretend you are a student in a fancy college!

So where should you stay? Well, where better than the University Arms Hotel to really immerse yourself in the spirit of the city, which hosts one of the most prestigious universities in the world? This stunning boutique hotel is, in fact, packed with little touches and nods to the literary world and to the essence of Cambridge, with its bicycles, punting and culture. The suites are named after writers or poets and each one has a curated bookshelf with the author's books, perfect for an evening read. There is also a library on the ground floor

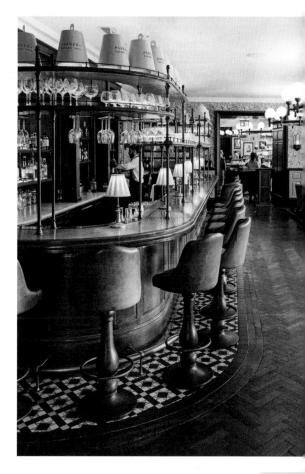

*The University Arms is full of nods to Cambridge.*

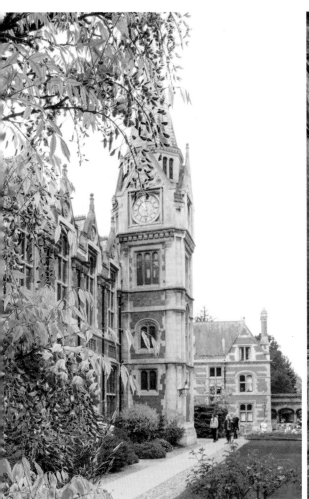
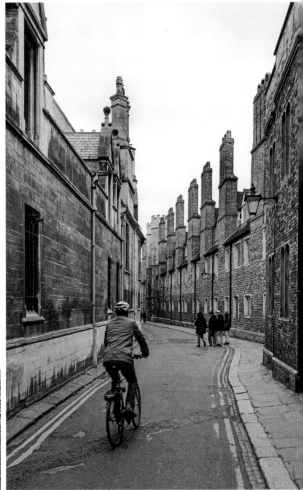

where you can have afternoon tea, drinks or just borrow a book. From its curated interior design, you wouldn't imagine that the University Arms is actually Cambridge's oldest hotel. Something we particularly loved about this hotel is that they gave us little hand-drawn maps to explore the city, with foodie tips, jogging trails, historic locations to visit and loads of ideas on what to see. Plus, you can take one of their pretty light blue bikes to explore and move around Cambridge like the locals.

So what's to see? Well, a lot! From the beautiful King's College with its chapel, the largest vaulted ceiling in the world, to the Fitzwilliam Museum and Trinity Lane, the location of Pier Paolo Pasolini's movie, *The Canterbury Tales*, to the Wren Library inside Trinity College. Legend says that Lord Byron kept a bear in his room while studying there. We don't know about that but for sure, but the library is home to the manuscripts of another literary great who's brought many a

child (and adult) so much pleasure, A. A. Milne – *Winnie-the-Pooh* and *The House at Pooh Corner*.

Of course, a must in Cambridge is punting on the River Cam. You can take a guided tour or try out your punting skills yourself, but be warned, it's way more difficult than it looks! It is the best way to explore the campuses, comfortably gliding along the river, beneath the famous Bridge of Sighs and Magdalene Bridge. Be sure to cross them by foot as they do have perfect views.

To get fuel for the day, have a Chelsea bun at Fitzbillies, a Cambridge favourite since 1920 – they are incredible! Whether you are watching the scholars go about their day along the city's cobbled streets or getting lost in all the campuses, we are sure you'll have the perfect weekend away and you'll treasure forever that feeling of walking down the university corridors, so rich of history, like some of the greatest minds used to do.

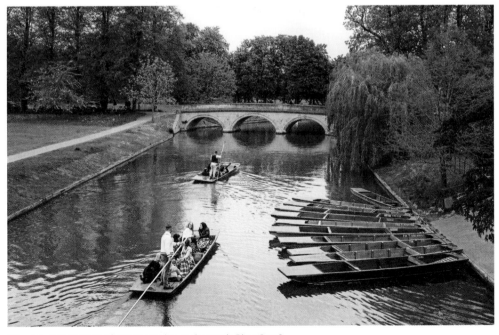

*Why not while away an afternoon punting on the scenic River Cam?*

# Oxford

 1h from London Paddington ⊕ 12 hours

Think Oxford, think beautiful old university colleges, students bicycling about the cobbled streets or punting on the river. It's a beautiful place and home to one of the most prestigious universities in the world, which draws students and tourists from around the globe. And for a compact city, it offers so much more to visitors. Its proximity to London makes it a really great day trip, as it's only one hour away by train. If you are looking for a relaxed trip, you will probably be able to visit two colleges on the day and have some time to have coffee and pastries in a cute café, a quick lunch at one of the markets (Covered Market is great!) and maybe fit in some punting.

The city is built around 38 colleges, which have almost 800 years of history. Christchurch College is probably the most well-known college in Oxford, the site of many a Harry Potter film and having birthed 13 Prime Ministers. If you are a Potter fan, definitely look out for Bodley Staircase, the Dining Hall – said to be the main inspiration for The Great Hall in the films – and the Cloisters, but go early as it is often packed with tourists battling to take photos. Also, did you know that Christchurch College is where Alice in Wonderland was born? The author Lewis Carroll, who studied and taught there, met a girl named Alice Liddell (daughter of the Dean of the college)

here and used to tell her magical stories during their boating trips, and at her request started writing them down, which was when *Alice's Adventures in Wonderland* were born.

Magdalen College is another great Oxford institution, founded in 1458. Its grounds are impressive and there's even a deer park, where you can spot the animals before heading off for a picturesque walk across the River Cherwell. Among the college's famous alumni are nine Nobel Prize winners and C.S. Lewis, author of the Narnia books.

If you head to Oxford during spring, you won't want to miss a stop at Balliol College, as its gardens will be covered in wisteria, daffodils and wallflowers. This is said to be the oldest college in town (although there is much debate around this) as it has been there since the thirteenth century. Equally beautiful is Trinity College, with its beautiful chapel, Dining Hall and large grounds, perfect for a stroll on a sunny day.

If instead you would like all of Oxford's college highlights in one place, New College is a great option. It has the most beautiful gardens surrounded by the original city wall, was used for the Harry Potter films and has some very notable alumni. Did you know that Hugh Grant and Kate Beckinsale both studied here?

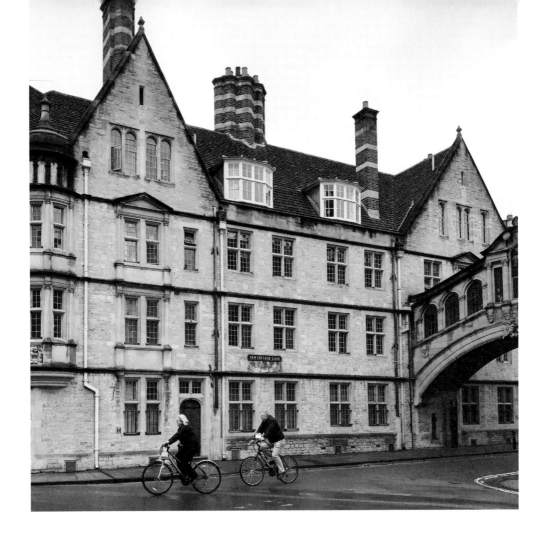

You can, of course, take advantage of one of the many university tours, if you're strapped for time, but want to wander the city. <u>Jericho</u>, one of Oxford's oldest areas and a bustling, popular destination for students and tourists alike, is worth a visit. Full of history, and once a red light district, today it's Oxford's boho neighbourhood, and a good place to rest your weary feet in one of the many pubs and restaurants.

+ INSIDER TIP

*Although the colleges are absolutely gorgeous and perfect for photos, the most picture-perfect spot in Oxford is probably the Bridge of Sighs. Hop on a bicycle if you can and cycle underneath this bridge on New College Lane and you will have a shot you will remember.*

# St Albans

## A CULTURED DAY TRIP

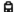 20m from London St Pancras 🕐 12 hours

St Albans is probably one of the easiest day trips from London, as it's a mere 20 minutes away from St Pancras Station. It's so close that many affluent city dwellers have decided to move there to escape the hustle and bustle, but still be close enough to commute, making it one of the wealthiest places in the UK. This historical British city is perfect if you want to spend a relaxed day away from town, wandering its pretty streets, shopping its markets and quirky shops and getting lost in its Roman remains. We personally love going there in autumn, as the red and golden leaves make everything even more picturesque.

Not many cities in England can boast St Albans' rich history. The Romans established this town, one of their largest in Britain, in the first-century BCE, but even before that, it was a capital for the Celts. The Romans called it Verulamium and it became a thriving city; it was named St Albans in the fourth century after the first-recorded martyred British saint.

If you head to St Albans on a Wednesday or Saturday, you may want to stop at the Charter Market. It's been operating for over 900 years and has over 150 stalls, where you can find all sorts of things. There are also lots of quirky independent shops and cafés you can pop into before heading to the real star of this town, the cathedral.

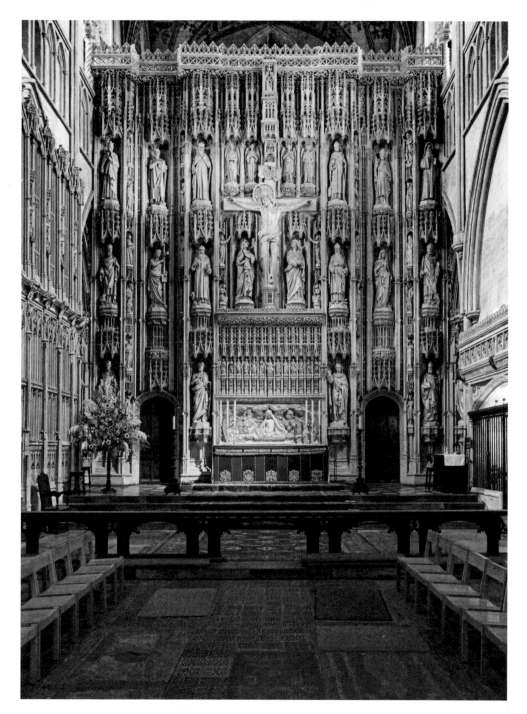

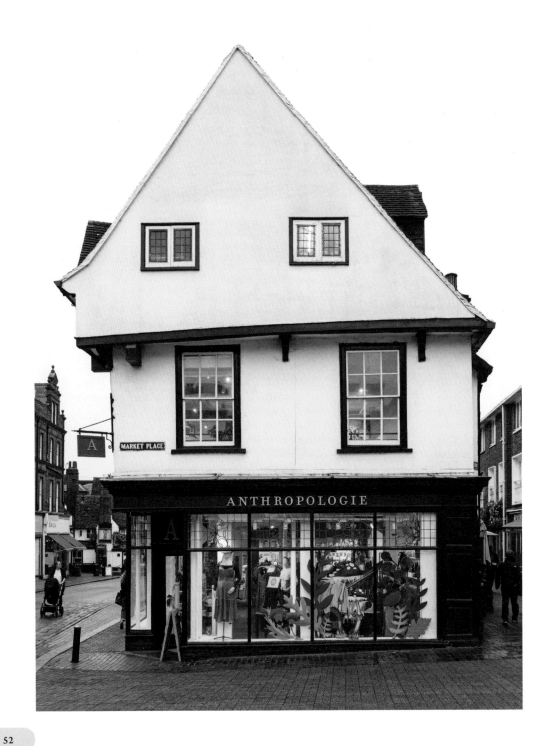

St Albans Cathedral was built in 1077 on the site where St Alban is believed to have been martyred. It's the second-largest abbey church in the country after Winchester. It also has the longest nave of any cathedral in England, at some 85 metres, and houses one of the most extensive collections of medieval wall paintings surviving today. The interiors are absolutely stunning, a photographer's dream . Entry is free, so there really isn't any excuse to avoid visiting, and, trust us – it's worth it.

Next stop is the nearby Verulamium Park, but if you are feeling hungry on the way you'll walk past Ye Olde Fighting Cocks. What's so special about this pub, we hear you say? Well, apart from the picture-perfect building, it's the oldest pub on record in England, dating back to the eighth century. It's a real St Albans landmark, so again no excuses, you need to go in, even just for a pint!

Back to the Verulamium Park, this is a great spot for an afternoon stroll on your way to the Verulamium Museum, which is built on top of the old Roman City. Here you will find ancient treasures and mosaics that were discovered during the many excavations of the town, plus some recreated Roman rooms. Just a few minutes away from the museum is the Roman Theatre

of Verulamium, which was built in 140 CE and is the only example of its kind in Britain, as it has a stage rather than an amphitheatre. The arena would have been used for anything from religious processions and dancing, to wrestling, armed combat and wild beast shows!

Time to head back to town, and if you are visiting either on a Saturday, Sunday or a Bank Holiday in the summer months, you may want to climb the 93 narrow steps of the Clock Tower to get the best view over the city before heading back to London.

+ INSIDER TIP
〰〰〰〰〰

*If you are looking for a good place to eat that is not a pub, then Lussmanns Sustainable Kitchen, with its garden views and ethically sourced ingredients, is a good option, along with Thompson St Albans, where you can enjoy a tasting menu.*

# Windsor

A RIGHT ROYAL SPA WEEKEND

 1h from London Paddington ⊕ 48 hours

Say Windsor and so many things spring to mind, Ascot, Eton and, of course, the famous castle, the oldest and largest occupied castle in the world. It was the official residence of the late Queen Elizabeth II, and it is where many royal weddings and ceremonies have taken place. This historic and iconic location, surrounded by beautiful countryside, is the perfect day trip from London, somewhere you can immerse yourself in British history and royal flare.

For many daytrippers, Windsor Castle is the first destination. There's a lot to see in this 1,000-year-old building and we recommend getting your tickets in advance for the castle and to take a guided tour.

Once you are done exploring and admiring the State Apartments and the grounds, head to St George's Chapel, where Harry and Meghan, the Duke and Duchess of Sussex, tied the knot. It's considered one of the most beautiful ecclesiastical buildings in Britain. Follow the cobbled streets to find and photograph the famous Crooked House of Windsor, squished between the Windsor and Royal Borough Museum and tiny Queen Charlotte Street, actually the shortest street in England!

So, what about that spa in the title, you may well ask? Well, a little further from Windsor is the elegant Fairmont Windsor Park. We definitely suggest heading there for a magical spa weekend to make your visit to Windsor really special (and not all about the castle and the royals). You'll absolutely love the luxurious and tranquil indoor and outdoor pools, the marble hammam and the Himalayan-salt-infused room. If you are feeling brave, we recommend trying the innovative cryotherapy chamber, where your body is exposed to -110°C to improve sleep, skin and tackle body fat. We tried it and, well, it was for sure an experience! If you are more into a proper pamper, we loved the Sandstone Massage where you are warmed with French handcrafted hot sandstone pods to improve muscle and stress relief. For the ultimate luxurious experience go for the Liquid Gold, Rose Quartz and Caviar Facial, which needs no explanation really! After you are all relaxed and pampered, dine at the 1215, the gorgeous in-house fine-dining restaurant and try the seven-course tasting menu, with wine pairings, of course. Truly special and one of the best ones we've ever had!

Fairmont Windsor Park has also recently seen the addition of ten actual treehouses, where you can sleep and feel like you are in the middle of a forest. They look stunning and they all have hot tubs and private balconies overlooking the forest, where you can request to have an outdoor massage, all while listening to the birds singing.

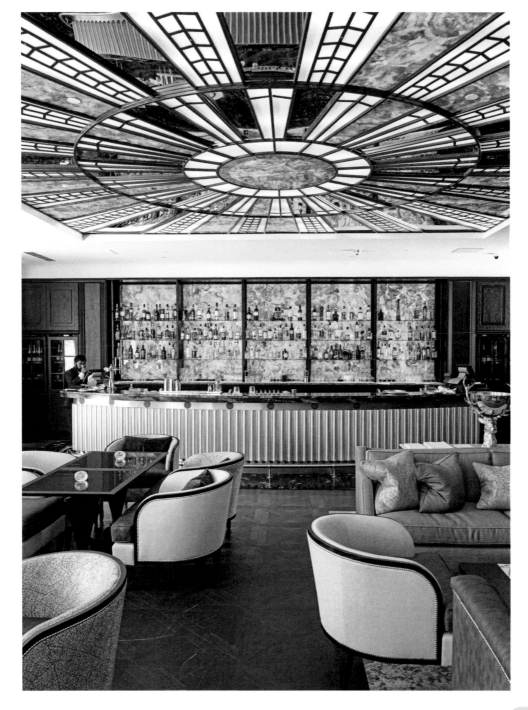

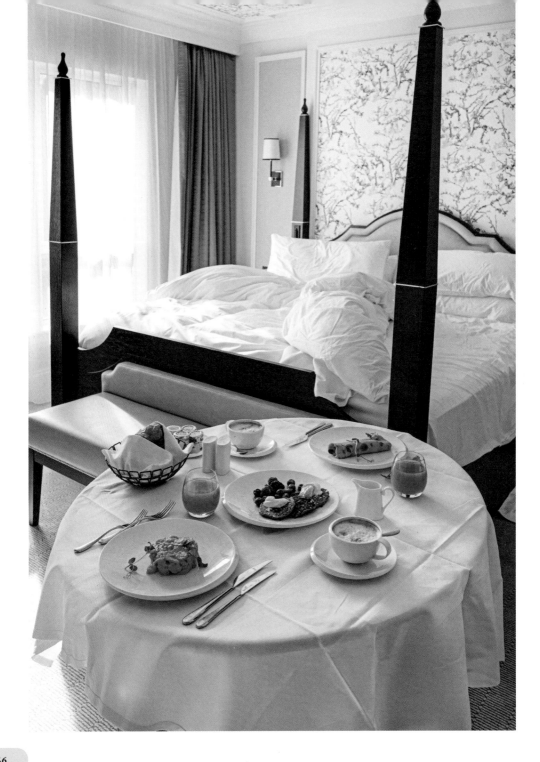

+ INSIDER TIP
〰〰〰〰〰

*For lunch, head to The Loch & The Tyne by Adam Handling, the perfect mix of luxury and classic British comfort food. It's his first 'restaurant with rooms' outside of London and so a perfect stop on your way back to the city.*

# Five Best Spas

Londoners do love a spa escape. And we are constantly asked for spa suggestions by our followers, so here are some of our favourites in the countryside. Don't get us wrong, London has some great ones, but that feeling of being far away from the city just hits differently.

### 1. COWORTH PARK *Ascot*
Based in Ascot, Berkshire, this hotel is part of the Dorchester Collection, so you know exactly what to expect in terms of quality. You can decide if you want to be relaxed or revitalised, to switch on or switch off. Just let the team know and they'll take care of you.

### 2. DORMY HOUSE *Cotswolds*
A lovely hotel situated in the Cotswolds, close to Broadway and Moreton-in-Marsh. What we love about this spa is the indoor/outdoor experience, but most of all the outdoor hot tub – perfect on a cold winter day.

### 3. THE SCARLET *Cornish clifftops*
One for the wow factor. This eco spa is set among the rugged Cornish clifftops. You can watch the crashing waves from the indoor pool or, even better, the outside hot tub.

### 4. LIME WOOD *New Forest*
The Herb House Spa at the Lime Wood in the New Forest is one you won't forget. It's spread across three floors, with an indoor pool, hot outdoor pool and log-lined sauna, and enjoys the most serene views of the forest. After your treatments, head to the Raw & Cured café to chill with some smoothies and juices.

### 5. FAIRMONT WINDSOR PARK  *Windsor Great Park*
The Fairmont really knows how to make an impression, set in 40 acres of Windsor Great Park. This state-of-the-art spa includes a 20-metre indoor pool, 18 treatment rooms, a hammam and a pretty pink Himalayan salt room. The is also a silent room with comfortable lounge beds, perfect after a session in the cryotherapy chamber, which exposes your body to temperatures as low as -110°C.

*Opposite: Dormy House*

CITY & TOWN

# Bristol

## THE GRAFFITI CAPITAL OF THE UK

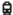 1h 30m from London Paddington ⏱ 48 hours

Bristol is one of those cities that most Londoners have visited at least once, driven either by their interest in street art and graffiti, the colourful houses in Cliftonwood or the great foodie scene. To see everything, we would definitely recommend a weekend, but as it's less than two hours from London Paddington, it can make for the perfect day trip.

Although home to many fine public and independent galleries and art spaces, such as Bristol Museum and Art Gallery, M Shed and the Arnolfini, for many, Bristol is the undisputed capital of street art and graffiti in the UK. The graffiti scene dates back to the early 1980s, but really gained momentum and global interest when one of the most notorious street artists in the world – Bristol-born Banksy – started creating his pieces here. There are currently 11 art locations in the city, either at their original locations, like his early works in Easton, or relocated to galleries, like M Shed on the dockside.

So what is the best way to discover Bristol's most interesting graffiti? Can you simply wander around and see it all? You most certainly can, but we would recommend doing one of the street art tours in the city, many of which are run by the artists themselves, who will share secrets and fun facts, in addition to taking you to the best

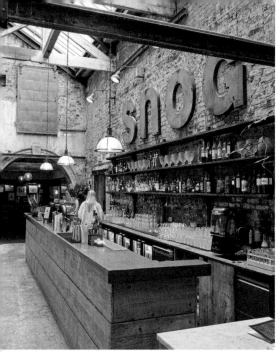

and most controversial graffiti in town. We went through a company called Where the Wall, where former street artist Alex took us to some of the best and most interesting pieces in town, starting at College Green, where Banksy completed his famous Well Hung Lover, and terminating in Stokes Croft, where there is graffiti pretty much at every corner.

Tours last around two-and-a-half hours as there is a lot to see, but if you are short on time, you can always do a self-guided tour or simply wander around Nelson Street in the city centre, and then head towards Stokes Croft, the quirkiest and coolest part of town, which reminds us a lot of Shoreditch in east London, with its many independent shops and restaurants.

There are, of course, many other great things to do in the city. One of our favourite areas is Clifton, a village within the city, steeped in Georgian architecture and full of boutiques and little restaurants, the prettiest spot being Clifton Arcade. From here, you can walk to the Clifton Observatory for the best views of the Clifton Suspension Bridge, a real masterpiece designed by engineer Isambard Kingdom Brunel, which spans the gorge between the River Avon and the city. Only a 20-minute walk from the observatory is Cliftonwood, the most peaceful neighbourhood in town, known for its multi-coloured Victorian terraced town houses. Be sure to visit the beautiful Ambrose Road if you are looking for the perfect Insta-shot!

Moving towards the centre, you can't visit Bristol without walking along the Harbourside and boarding the SS Great Britain, another gem designed by Brunel. This ship was of significant importance as it was the first great ocean liner – designed to transport passengers from Bristol to New York in 14 days. The inside is a replica of how it would have looked when the Great Britain crossed the Atlantic – even down to the odours and sounds! A short walk from the ship is Bristol Marina, where you can see the fishermen's boats against a beautiful backdrop of colourful houses.

Now that you hopefully have a good feel for the city, it's time to find you a place to stay and some spots to eat. Our absolute favourite hotel in Bristol, and very much in line with the city's vibe, is the Artist Residence, sister to the Brighton establishment. It's housed inside a Grade I-listed townhouse and former boot factory in Portland Square and is packed with art and vintage chic objects. You can see the bohemian style of the Artist Residence throughout the hotel, with the bar a must if you are looking for a good spot for drinks, even if you are not actually staying in the hotel.

When it comes to restaurants, you really are spoilt for choice in Bristol. If you are in the Stokes Croft area after your art tour, definitely drop by local favourite Poco Tapas, or Nadu, a cute restaurant that serves Sri Lankan Tamil cuisine (be sure to get the dosa).

If you are more central and looking for a lunch spot, we suggest you visit St Nicholas Market, which has been there since 1743 and is considered to be one of the best in the UK. There are numerous street food stalls; we would recommend trying the pies at Pieminister, a Bristol-based pie company.

As mentioned, there are plenty of top-tier restaurants, several Michelin-rated, including George Livesey's Bulrush, in Bristol's leafy suburbs, and the tiny Korean Bokman, on Nine Tree Hill. Explore Bristol and find the right one for you. There's so much choice.

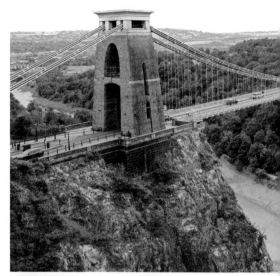

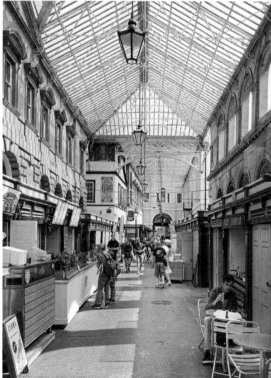

+ INSIDER TIP
~~~~~~~~

Feeling inspired after the art tour? Then why not do a Spray Art session in Stokes Croft. This fun activity is run by Where the Wall at Hamilton House and introduces you to stencil art. You can even create your own artwork to take home.

Bath

CITY OF ROMANCE

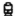 1h 30m from London Paddington ⊕ 48 hours

Bath is, in our opinion, one of the most romantic cities in the UK, with its gorgeous architecture, golden-hued stone and elegant atmosphere. So easily reachable by train, it makes for a great day trip or a weekend away, relaxing in one of the many luxurious hotels with a spa. That may well be the first thing that comes to mind when you think about Bath – and no wonder, considering that the city was actually built by the Romans, around the thermal spa, for the pure pleasure of relaxation. It has remained a well-being location since then, being a popular destination for high society in Regency England and the site of many a Jane Austen.

Unfortunately, while you can't bathe in the historic Roman Baths anymore, you can certainly visit them and get a feel for the fun the Romans used to have! From the Sacred Spring, to the remains of the Roman Temple and the perfectly preserved Roman Bath House, no visit to Bath is complete without a tour of this famous sight. If you want to see the adjacent Pump Room too, we suggest buying a combined ticket which also includes afternoon tea under the gorgeous chandeliers of this iconic room.

If you are looking to visit an actual spa, great news, you can head to the Thermae Bath Spa for a two-hour session where you can actually bathe

in what is the only natural thermal hot spring in the UK. Head upstairs to the rooftop pool for great views of the city – even better when dusk falls.

The Gainsborough Hotel is a great alternative if you are after something a little more sophisticated and probably less busy. You don't have to stay in the actual hotel to access their Spa Village, but if you do, you can take advantage of the in-house-only swim hours – and if you request the spa rooms you receive thermal waters directly to your room's bathtub. The spa itself is beautiful, with columns, glass ceilings and thermal water circuits – and even a chocolate fountain to keep you hydrated. Sort of.

Spas aside, what differentiates Bath from other UK cities is the gorgeous, monumental Georgian architecture, which makes you feel like you are on the set of *Bridgerton*. (You actually are, by the way, and can even go on a walking tour.) Take a stroll along the historic Circus, and the iconic Royal Crescent, a majestic 150-metre curve, lined with 30 Grade I-listed terraced houses, the location of many a historical TV drama. Built between 1767 and 1774, the buildings' façades remain beautifully preserved. Some are still private residences: a few are houses, others have been converted into flats overlooking the lovely, well-maintained lawn in front.

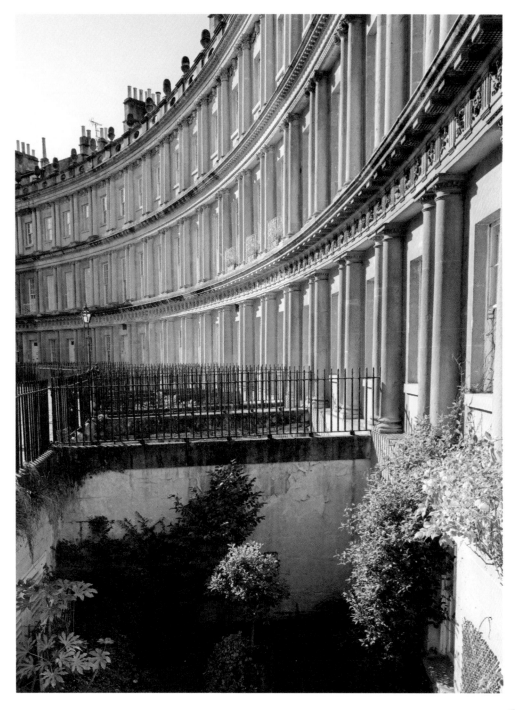

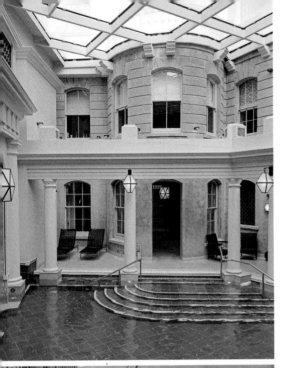

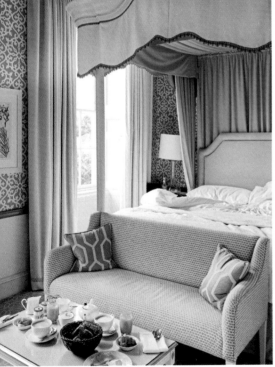

No 1 is a museum, faithfully restored to show how the houses might have been decorated in the late eighteenth century. And surprise – number 16 is a stunning hotel – The Royal Crescent Hotel & Spa, definitely the place to stay in the city if you want to splurge on a romantic weekend. The rooms are stunning and we can easily say this is the most romantic hotel in Bath, with its luxurious surroundings and restaurant (there's a great tasting menu). It is also one of the few landmark buildings in the world that you can sleep in, and it is so special to enter the doors of this townhouse and wake up in the famous curve. Even if you can't stay here, you can get a peek inside by booking afternoon tea in the surprisingly large garden!

Bath is not short of romantic restaurants. Our favourite is the Italian Sotto Sotto, meaning 'down, down', where you can go for a candlelit dinner in an underground stone, vaulted cellar. The food is authentically Italian and the atmosphere top-notch. And before that, make sure you take a sunset stroll along the famous Pulteney Bridge, one of only three bridges in Europe that is lined with shops. Can you guess the other two? Built in 1769 by Robert Adam, it is one of Bath's most photographed places. But then, there are so many to choose from.

+ MAKE THE STAY LONGER

Bath is only 15 minutes away from Bristol by train, so even if you are short on time, you could visit both in a day. Alternatively, they make for the perfect weekend getaway. Spend a night in each city and catch the Great Western Railway back to Paddington.

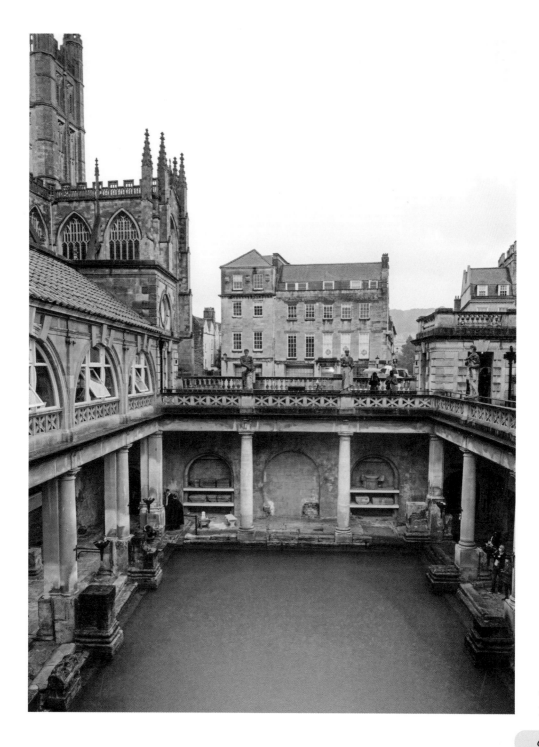

Bradford on Avon

A PICTURE-PERFECT LOCALE

🚆 3h from London Paddington

🕐 48 hours

Bradford on Avon must be the most pleasant surprise we have had when exploring the British countryside. We had been invited by the beautiful Widbrook Grange, a boutique farmhouse, for a staycation, and for once didn't do our research – we just hopped in our borrowed London Morgan and headed to this town in west Wiltshire.

Bradford on Avon is an ancient town, once a centre for textiles. The town is shaped by its history, with large former woollen mill buildings lining the river; most of the houses on the hill are also former spinners' and weavers' cottages. The town bridge over the River Avon still retains two original arches from the thirteenth century and is one of the main attractions. Also interesting is the Tithe Barn, one of the largest medieval barns in England which belonged to Shaftesbury Abbey (see pages 76–77). It has been used as a setting for many a British TV drama, including *Wolf Hall* and *The White Princess*.

Like any self-respecting fairy-tale town in England, Bradford on Avon is full of unique independent shops and cafés to check out. Our favourite building in town is The Bridge Tea Rooms. The exterior has a Hansel and Gretel feel and it has the cosiest of dining rooms, perfect if you fancy an afternoon tea.

This picture-perfect village is a three-hour journey from London, so we would recommend spending a night there, so you don't have to do everything in a rush – and you can breathe in the countryside air. For your stay, we couldn't recommend Widbrook Grange more. This boutique hotel is half a mile from the town and it's an easy walk along the canal. It's a converted Georgian farmhouse with rustic interiors that take you back in time. If you fancy dinner, The Kitchen Restaurant serves traditional farmhouse dishes perfectly in line with the hotel's vibe. It also has a separate vegan and gluten-free menu.

+ MAKE THE STAY LONGER
〰〰〰〰

Bradford on Avon is close to many of England's most beautiful attractions. If you are heading there by car, we would recommend stopping at Stonehenge. Also, if you find out how they managed to place those heavy stones there 5,000 years ago, do let us know!

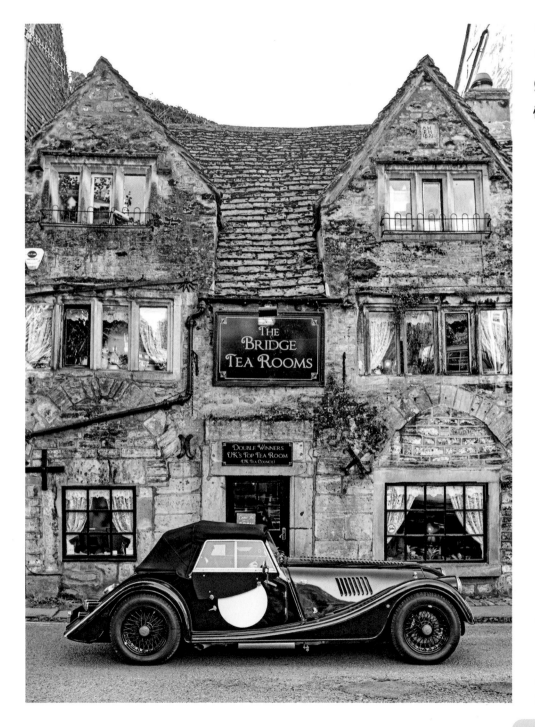

Wells

🚗 3h by car 🕐 12 hours

The tiny medieval city of Wells has only 12,000 residents. Its small size makes it the perfect day trip from London, with its fascinating cobbled streets and ancient architecture.

Located in rural Somerset, near the beautiful Mendip Hills (worth a visit if you like walks), Wells looks more like a market town than an actual city and it can thank its beautiful thirteenth-century cathedral for the right to be called such. The cathedral is internationally renowned and its façade, adorned with around 300 medieval statues, is one of the most impressive in Europe.

Looking at the West Front for the first time is a guaranteed 'wow' moment! In medieval times, the whole façade was full colour, like a gigantic painting! Some other features worth checking out are the iconic 'scissor arches' inside the cathedral, that, yes, are beautiful, but were actually constructed as an engineering solution to save the whole thing from collapsing. Definitely stick around to see the fourteenth-century astronomical Wells Clock, which chimes every quarter of an hour. It puts on quite the show and it can even tell you how many days it has been since the last full moon. It is thought to be the oldest clock in England and even claims to be the world's oldest working clock with a dial – although there is quite the debate on that!

Now, our favourite thing to see (and photograph) in Wells is Vicar's Close, a cul-de-sac originally built to house the vicar's choristers and keep them away from possibly succumbing to temptation. This extremely picturesque cobbled street is the oldest residential street in Europe and the only intact medieval street left in England. How cool is that? We are sure the residents of this super photogenic street feel very special indeed.

+ INSIDER TIP

Wells is the perfect base from which to explore Somerset. If you are a foodie, visit the original Cheddar George Cheese Dairy and the prehistoric Cheddar George caves. This traditional cheese originates from the 1800s, thanks to some hardened milk and a forgetful milkmaid. If you fancy a walk, go up the Glastonbury Tor from Glastonbury village (where the famous festival takes place) to see the mystical location where some swear King Arthur found his Holy Grail.

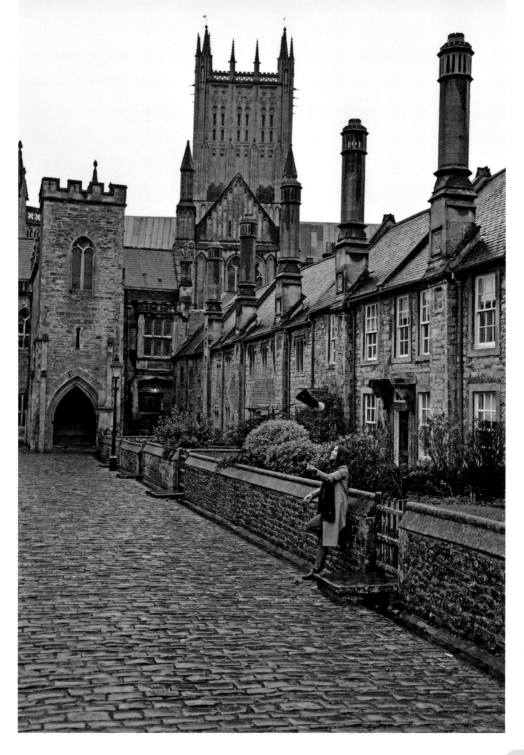

Winchester

WALKING IN KEATS' FOOTSTEPS

 1h from London Waterloo ⊘ 12 hours

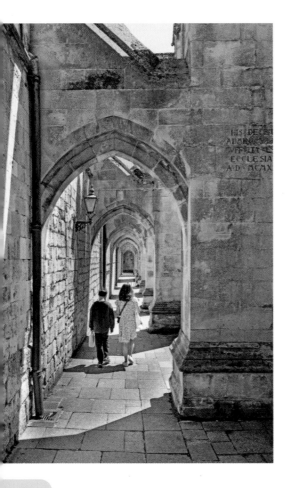

What is so interesting about the city of Winchester? Well, many things. It's a place full of history, but if the lines 'Season of mists and mellow fruitfulness, close bosom-friend of the maturing sun', mean something to you, you'll be pleased to read on further.

This vibrant cathedral city in Hampshire has played host to many a famous resident, but English Romantic poet John Keats stayed here in the summer to late autumn of 1819. Inspired by the seasonal beautiful landscapes of the city, on his return to London in September of that year, the Romantic poet penned his famous ode 'To Autumn.' Apparently Keats really enjoyed a daily stroll in the city, starting at Winchester's beautiful cathedral and walking along the picturesque water meadows to reach the Hospital of St Cross.

So, if it's good enough for the poet . . . let's retrace his footsteps. And give yourself a couple of hours to enjoy the sights.

We suggest beginning the walk at the information point in the Victorian Guildhall to pick up a detailed map of all the stops, as this has become a popular promenade with locals and visitors alike. They say Keats' lodge used to be near there so we can start the walk as he used to do. The first proper stop is, in the poet's words, the 'beautiful front' of Winchester Cathedral [1].

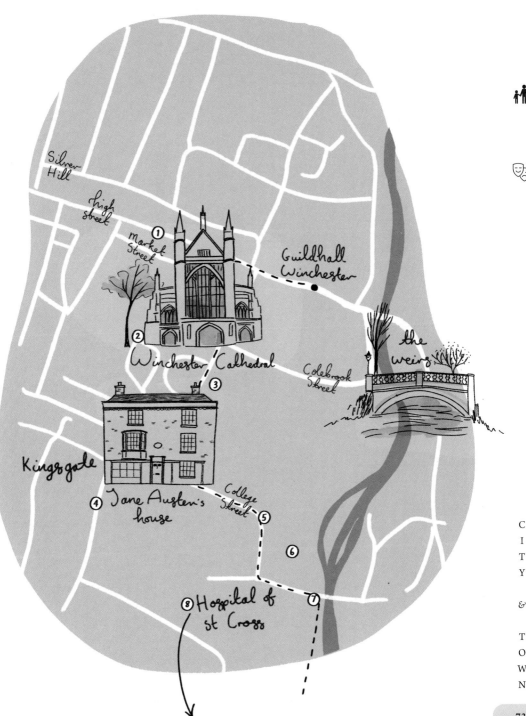

Silver Hill

high street

market Street

① Winchester Cathedral ②

Guildhall Winchester

the weirs

Colebrook Street

③

Kingsgate

④ Jane Austen's house

College Street ⑤

⑥

⑦

⑧ Hospital of St Cross

To reach it you just have to walk along the High Street and take the second left into Market Street. Usually there is a cute pastel green van selling delicious treats and iced coffees, so this is a good opportunity to grab something for your walk. It's definitely worth going inside the cathedral and walking the same aisle as Keats did when he was reading letters from his girlfriend, Fanny Brawne.

Left of the cathedral, walk through some beautiful stone arches – an Insta-worthy opportunity – to end up in the Inner Close [2], a tranquil green square surrounded by many interesting buildings. These include the Chapter House, which was where the monks used to meet to discuss business matters, the fourteenth-century Deanery, and the Pilgrims' School, where the cathedral choristers still receive their impeccable musical education. There is also a little secret garden called the Dean Garnier Garden in the Inner Close of the cathedral. Opened in 1995, it's divided into three 'garden rooms' and features medieval and Victorian plants. Although designed well after Keats, it's perfect for a pit stop.

Now that you've seen everything there is to see in the square, you can walk away from the Inner Close through the beautiful gates of Cheyney Court [3], possibly the most photographed building in town, and past Kingsgate, one of only two surviving gates in the city. If you are looking for a special souvenir to take home, tucked away under the arches is a bookshop that sells vintage prints and gorgeous maps of England, some of them several hundred years old!

Continuing on College Street on the left, you'll see the house of Ms Austen [4], who spent the last weeks of her life at number 8 and finished her last novel, *Persuasian*, there; then walk onto the prestigious and much photographed Winchester College [5], one of the oldest public schools in England. We definitely recommend taking the tour inside – we think it's a bit like being in Hogwarts!

Coming to the end of College Street, you have the chance to see Wolvesey [6], the home of the bishops of Winchester – it's definitely somewhere we would live too!

After all this history, it's well past time for a relaxing stroll along the water meadows [7], which follow the River Itchen. Follow the signs and you'll reach the most idyllic path between the river and lush greenery. Rolling hills, butterflies and all the beautiful wildflowers . . . of course, we can see why Keats was so inspired!

The last stop of the walk is the Hospital of St Cross [8], a beautiful medieval almshouse with an interesting tradition that continues to this day. Knock on the wooden door and ask for the Wayfarer's Dole at the Porter's Lodge and you will receive a cup of beer and a morsel of bread, just like the pilgrims and hungry travellers who visited here some 800 years ago. Circle back and you'll find yourself back in town.

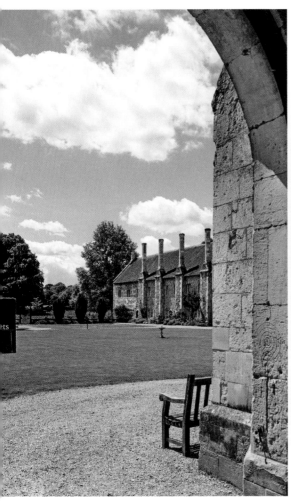

+ INSIDER TIP

~~~~~~~

*While we recommend doing the walk in autumn if you want to experience what Keats saw, but that does mean an increased chance of rain and bad weather. Late spring and early summer are when all the wildflowers bloom and the lush green environs are at their best – and you definitely have more chance of a warm, sunny day.*

# Shaftesbury

## AN ADVERT-WORTHY VIEW

 2h 30m by car 🕐 12 hours

Welcome to beautiful Shaftesbury – home to one of the most romantic spots in England!

In this small, historic market town, perched on a hill above North Dorset's rolling countryside, is the picture-perfect Gold Hill. This Insta-famous, steep cobbled street was immortalised by the baking company Hovis in an iconic 1973 TV ad, voted Britain's favourite of all time – and we have to say, with such a picturesque setting, we can definitely see why! So if this place looks familiar to you, this is possibly the reason. The ad, showing a boy struggling up the hill with his bike and a basket full of bread, launched acclaimed film director Ridley Scott's career. The other reason you may recognise Shaftesbury is because it's on the literary map, featured in several Thomas Hardy novels – *Tess of the d'Urbervilles, Jude the Obscure* – and the setting for many a film, including *Far from the Madding Crowd*, another Hardy classic.

Filming aside, the view of the thatched cottages and the countryside looking down from the top of Gold Hill is truly something to remember, especially when it's bathed in that magical West Country dusk light. Surely special in every weather, we visited on a rainy day – and we have to say it looked charming.

If you want more open views over the countryside, head through the central square to Park Walk, from which you can clearly see across Hardy's much-loved Blackmore Vale. From here you can go along the promenade to reach Pine Walk and Castle Green, where King Alfred's Tower stands and from where you can spot Glastonbury Tor on a clear day.

Pop into the Swans Yard for a coffee and cake break at the Ugly Duckling Café and to check out the unique artisan shops in the square.

## + INSIDER TIP

*Thursday is market day in Shaftesbury, so the streets are packed with stalls selling local produce and handmade crafts, and it's when the town gets very busy and vibrant. If you want to take a picture of Gold Hill when it's empty, without people in the way, we would strongly suggest you avoid this day.*

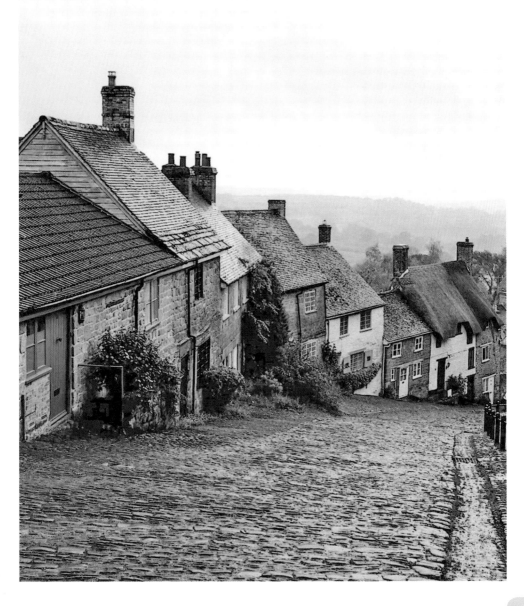

# Brighton

If the first things that come to your mind when we say 'Brighton!' are screaming seagulls and fish and chips, think again! While there is definitely all of that, and more, Brighton is also a hot spot for creativity and it's packed with art events, festivals and cool galleries. Always a popular destination, from Regency times onwards, and a favourite with the LGBTQIA+ community, where PRIDE is a huge, joyous celebration annually, it's a city that fits all – the culture and beaches both family- and festival-friendly, the shops, bars and restaurants delighting many an adult.

Sure, you must visit all the iconic attractions once you are in town, but here we are going to guide you, if you are curious, to explore a few of our favourite places, ones with an artsy vibe. First, there's no better place to set up your home away from home for the weekend than the Artist Residence. We love this little boutique hotel, with a bohemian charm of its own, and perfectly located on Regency Square, with pretty views over the seafront. Each one of the 24 rooms is different in its eccentricity and has the mark of local artists, with the unique artworks decorating its interior.

You should start your visit with one of the most famous places in the city, so from the Artist Residence walk to the iconic, Grade II-listed Brighton Palace Pier for a carousel ride and a stroll along the promenade. We love the retro vibe of this place, which takes you back in time and makes you feel like you are a teenager in an eighties American movies. It's romantic and extremely photogenic at sunset – it makes for a nice Instagram shot too. Once you are done spending all your coins on the arcade games and taking photos, and you've eaten all the ice creams and churros you can take, it's time to really explore this happy city in all its colours. It's impossible not to feel the inclusive and flamboyant vibe of Brighton, and walking about its busy streets is a part of that.

Talking about eclectic, did you know that there is an actual Royal Pavilion, built as a seaside home for George IV? Brighton was once a favourite destination for the aristocracy, and George, Prince of Wales (later George IV), commissioned John Nash, no less, to build a home here for him. The Royal Pavilion is the result. It would not look out of place in India and it's worth a visit for the beautifully decorated music and banqueting rooms alone. Plus, there are the impressive grounds, which are a wildlife haven. And if that's not enough, there's a secret tunnel linking the Pavilion to the Brighton Dome, once George's stables.

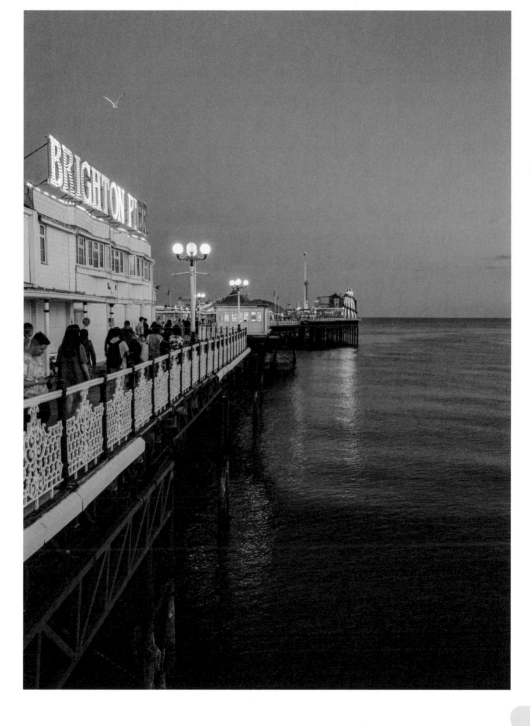

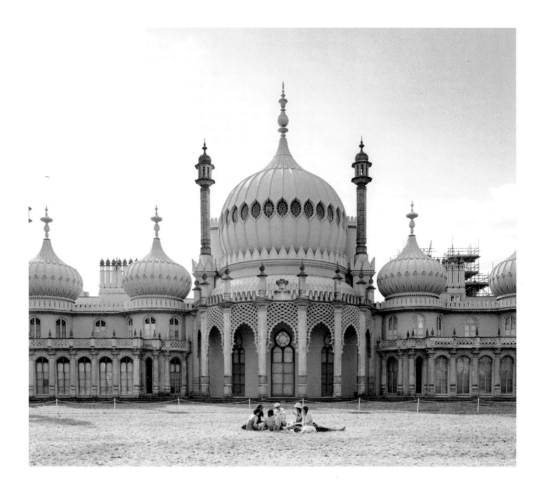

So, from the Pavilion walk to the <u>North Laines</u>, one of the best areas to get a feel for Brighton and also potentially find some hidden treasures. Indie clothing stores, such as <u>Jump the Gun</u>, specialising in menswear from the sixties, and <u>Snoopers Paradise</u>, a flea market essentially, featuring over 90 unique traders selling everything from comics to clothes, line the colourful streets, making it a true heaven for vintage shoppers.

For a coffee break, we'd head to <u>The Flour Pot</u>, an artisanal bakery. The love child of Oliver Hyde, the Sydney Street shop is the flagship of several outlets, mainly in Brighton and Hove. If you want lunch or dinner, a must is Isaac At, which serves very inventive small dishes, with a low-mileage-centred menu.

Next, brace yourselves for some more shopping and the cute independent boutiques of the cobbled alleys of <u>The Lanes</u>, just a 10-minute walk. These narrow pathways, once home to the fishing village that Brighton was, now host some pretty jewellers and antique shops. Among our favourites are <u>Pecksniff's</u>, a gorgeous shop that specialises in locally made and bespoke

perfumes, fragrances and home products – we particularly love the ice tea and fig combination!

If you are into jewellery, there are definitely many places to check out in The Lanes, but Baroque Bespoke Jewellery stand out for their complex designs and personalised engagement and wedding rings. They can even give new life to old family heirlooms, turning them into something more contemporary. For eating in this area, The Flint House has good-quality food and great cocktails, with a wonderful rooftop terrace.

Work off your lunch with a walk east along the promenade to find villagey Kemptown, once known as the artists' district, now a favourite with the LGBTQIA+ community. You'll find pretty streets such as Sussex Square, flea markets, fun bars and relaxed coffee places. One of the best

is Café Marmalade for their delicious brunch, pastries and takeaway coffee.

Walk along St James Street to find creative outlets and antique shops but, more importantly, if you visit during May, or in November or December, watch out for Artists Open Houses, a festival where many creatives in Brighton (and neighbouring Hove) open their private houses and studios and leave their work on display for the public to peruse and/or purchase. It's perfect for a snoop, too!

Last stop is Seven Dials, which looks a little like Notting Hill, with its pretty, often highly colourful houses. Start from gorgeous Clifton Terrace and work your way around the neighbourhood to find Victoria Street and Powis Square. From here you can spot Brighton's smallest art gallery, the Dog and Bone, and even a miniature museum of curiosity called Anna's Museum on Upper North Street.

Come back to the Artist Residence for a signature cocktail and then head across the road to Michael Bremner's restaurant, Murmur, situated in The Arches on Brighton's seafront, for a sunset dinner on its terrace (if the weather's good). It's the sister restaurant of the award-winning 64 Degrees, in The Lanes.

For your second day, let it all be about the beach. Whether it's summer or winter, you'll love an atmospheric walk along the pebble beach and for sure you'll encounter something or someone interesting. Head to Shelter Hall, with its seven kitchens, for lunch to find a wonderful array of street food, local craft beers and live music.

If you notice something looming in the sky and wonder what on earth it is, go investigate. Jump on the 20-minute pod ride in the sky, care of the British Airways i360. Of course, we recommend going at sunset to take advantage of

the panoramic views, and when it's sunny you can even see the Seven Sisters white cliffs, so bring your camera!

If you have not had enough of art talk, check out <u>Fabrica</u>, a former Regency chapel, in Duke Street, which showcases visual art installations. Or head to the <u>Brighton Museum and Art Gallery</u> in the Royal Pavilion's gardens, to check what exhibitions are on.

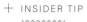

+ INSIDER TIP

*You can't talk about Brighton without mentioning Fringe, the largest arts festival in England. Held every May for over four weeks, it completely takes over the city. If you want something a little more low key, join the locals eating and drinking at the Brighton and Hove Food and Drink Festival, which happens in April and September.*

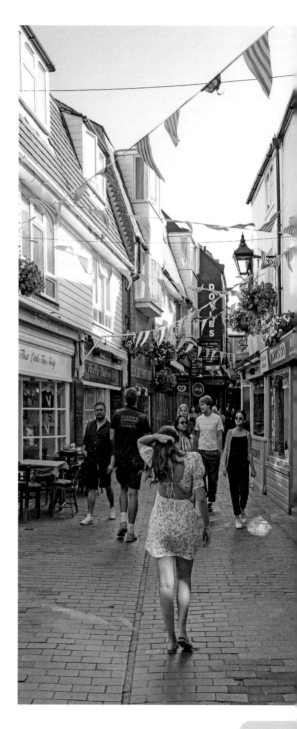

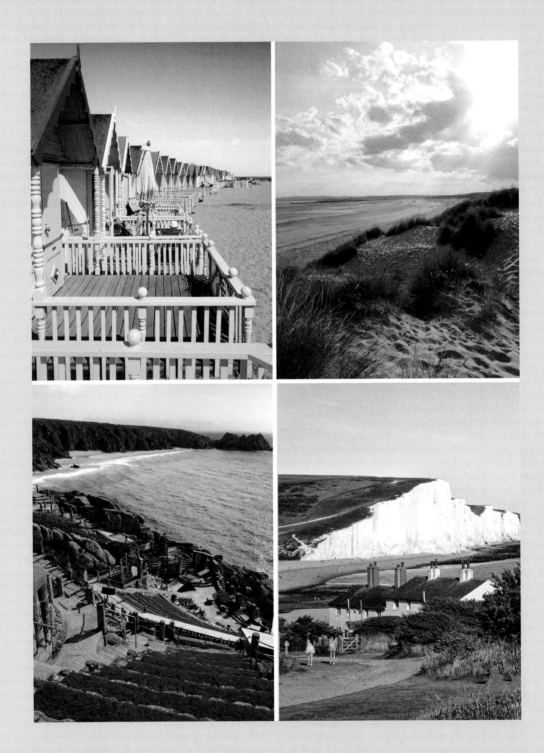

# COAST

---

SEASIDE TRIPS. Shoes off. *Hats on.* The Great British summer. *Seagulls.* Fish and chips. Stolen fish and chips. ICE CREAM. Sticky hands. Golden sands. Sea breeze. White cliffs. *Where is the nearest beach?* Let's go. Fresh oysters. Seafood platters. JURASSIC COAST. Summer days, longer days. Catching the sunset. Where is this place? CORNWALL. Blue skies. Blue waters. ENGLISH RIVIERA. *Not so bad after all.*

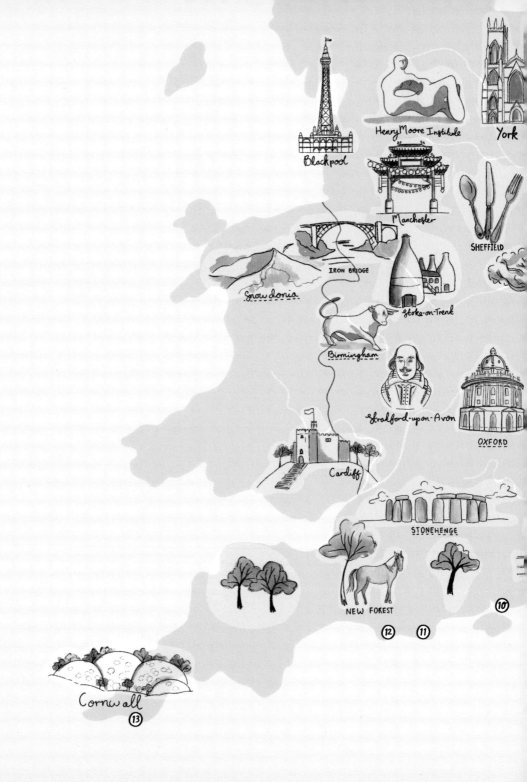

Blackpool

Henry Moore Institute

York

Manchester

SHEFFIELD

IRON BRIDGE

Snowdonia

Stoke-on-Trent

Birmingham

Stratford-upon-Avon

OXFORD

Cardiff

STONEHENGE

NEW FOREST

⑩

⑫

⑪

Cornwall

⑬

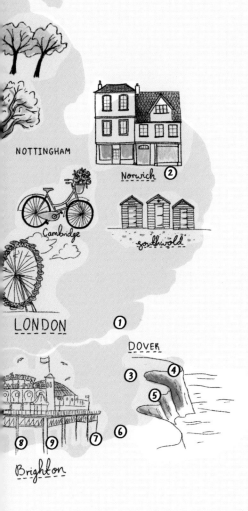

NOTTINGHAM

Norwich ②

Cambridge

Southwold

LONDON

①

DOVER

③ ④
⑤

⑥ ⑦

⑧ ⑨

Brighton

# Mersea Island

## PASTEL BEACH HUTS AND TOP-NOTCH SEAFOOD

 2h by car 🕐 12 hours

+ INSIDER TIP

*The Strood can become impossible to cross when the infamous high tide reaches Mersea Island. Check the tide times before you travel on the causeway to avoid any bad surprises or you may get stuck on the island, transforming this day trip to a weekend away instead!*

Nothing says day trip to the beach more than Mersea Island! Pick a hot, sunny day for this one and pack your prettiest flowy dress for a picture by the beach huts. If you have already heard of Mersea Island, it's probably because you've seen these drop-dead gorgeous pastel beach huts all over Instagram. You might not know that Mersea is an estuary island linked to the mainland by a causeway called the Strood and that it is actually in Essex! Not so far from London then, but when you're there you feel like you're miles away. The island is divided into East Mersea, where the nature reserve is, and West Mersea, the liveliest part of the island.

The island is famous for its delicious seafood, so if you visit, it is the perfect opportunity to eat your bodyweight in shrimps! The most famous places are The Company Shed in West Mersea, for unpretentious (and inexpensive) but delicious seasonal seafood platters, and the West Mersea Oyster Bar, both once closely guarded secrets by locals but now raved about by residents and visitors alike. Be prepared to queue though, or go way before midday, if you want to snatch a plate fast. Needless to say, the famous Colchester native oysters are an absolute must try.

Also, don't miss out on trying a local wine from the Mersea Island Vineyard. The Romans are reported to have grown vines on the island oh so long ago. We couldn't resist buying a bottle of delicious white from this small vineyard to bring home with us – it was great with some seafood pasta. If you are more into beer, though and you are feeling adventurous, check out the Mersea Island Brewery, a microbrewery nearby that serves an award-winning stout made with oysters!

For the perfect day in Mersea, we follow the relaxed vibes of the island. We love walking along the beach from the beach huts in West Mersea to the old town, but why not take a 20-minute boat ride around the bay?

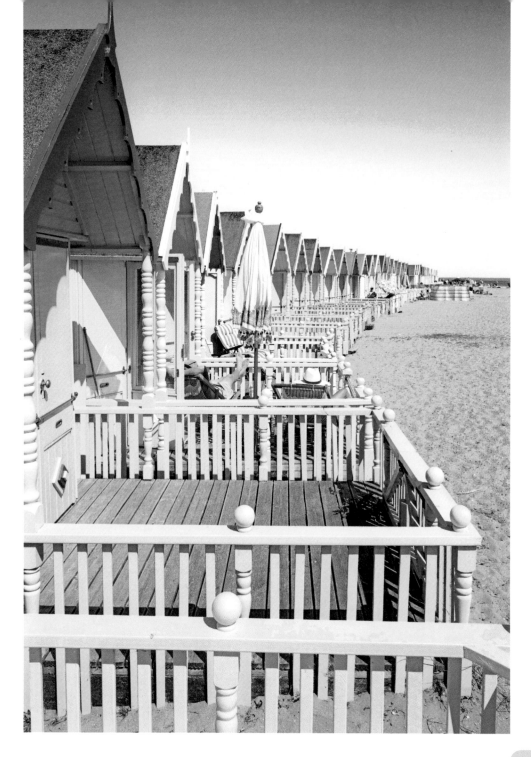

# The Norfolk Broads

## IN THE WILD BETWEEN WATERWAYS AND SEALS

🚗 2h 45m by car ⏱ 12 hours

Located in the east of England, with an unspoilt, golden sandy shoreline extending 90 miles, Norfolk makes for the perfect beach destination and offers plenty of relaxation spots, family seaside accommodations, plus there's all the history and culture. We thought change it up a bit and introduce you to Norfolk's wild side – its unique Broads, nature reserves and unusual wildlife inhabitants.

Norfolk is famous for many things – Nelson, Cromer Crabs, Colman's mustard – but the Broads, the humanmade canals that zigzag through the county, are one of the things people know best. A national park, it hosts a beautiful natural habitat, a mix of wetlands, open waters and woodlands. This makes for such a distinctive landscape. The waters are slow moving and free of any locks, making them completely and easily navigable. So, what better way to explore the Broads than by boat?

There are many boat hire companies around, with different vessels and prices, depending on the experience you are searching for. If you are planning to centre your weekend away on the Broads, why not hire a boat for the weekend and drift along slowly. Some boats truly look like mini yachts and with a bit of imagination you'll feel like you are in the South of France for the weekend!

We suggest looking at the Herbert Woods website for a wide range of cute boats suitable for the waterways. It also suggests different routes depending on the duration of your trip. We'd recommend at the top of your list visiting Ludham village with its medieval church, the ruins of St Benet's Abbey, Fairhaven Woodland and Water Garden – 130 acres of wild, natural and cultivated plantings – and the vibrant village of Horning, with its pretty riverside houses, restaurants, cafés and delis. That would make for a perfect three-day journey along the Broads. There are many mooring spots along the way so you can hop out easily and explore your surroundings on foot.

Alternatively – and this is really unmissable – you could hire a boat for the day or for a couple of hours. We tried Richardson's Boat Hire and it was just perfect. We loved our boat, which was really easy to manoeuvre and it was fun seeing boats of every dimension sailing along with us, looking at the pretty scenery and envying all the gorgeous backyards of the river-facing houses and cottages.

For your lunches and pints in the sun, you'll be spoilt for choice but if you are looking for something a little more refined, we recommend the Norfolk Mead Hotel, a Georgian country house boutique hotel. It is perfectly located on eight acres of grounds, right in the heart of the Norfolk

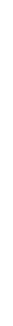

Broads, on the banks of the River Bure. We loved the laidback atmosphere and delicious food.

So, what can you spot while navigating the river? Well, the area has a diverse range of wildlife. Keep your eyes peeled for colourful kingfishers, silent herons and all types of migrating birds, such as the busy, yellow, fork-tailed Siskin. Plus, there's the diminutive Chinese water deer and distinctive Swallowtail butterfly, only found on the Broads. And if you are lucky you might even spot an otter!

Last but not least, head to the very eastern side of the Norfolk Broads to find the coastline, its unspoilt sandy beaches and Horsey Gap. What's there you might ask? Only the cutest animals ever! Seals. Attracted by the salty water of the North Sea combined with the fresh water of the Broads, seals absolutely love this spot and can be found sunbathing on the shore or taking a swim in the sea. Head there during the winter months (late October to mid-February) to see the adorable white seal pups with their mums. There are viewing stations from which to observe the seals without disturbing them. The nearby lovely beach of Winterton-on-Sea is another spot that is becoming quite popular with seals, plus it has very cute, colourful holiday cottages, which are truly picture-perfect.

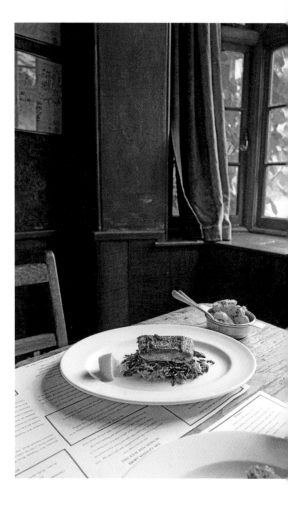

+ INSIDER TIP
〜〜〜〜〜

*There are also many stately homes worth visiting, such as the stunning Sandringham Estate, Houghton Hall and Felbrigg Hall. Also, the incredible gardens of East Ruston Old Vicarage are something you'll really remember, so you should add that to your list, too!*

C
O
A
S
T

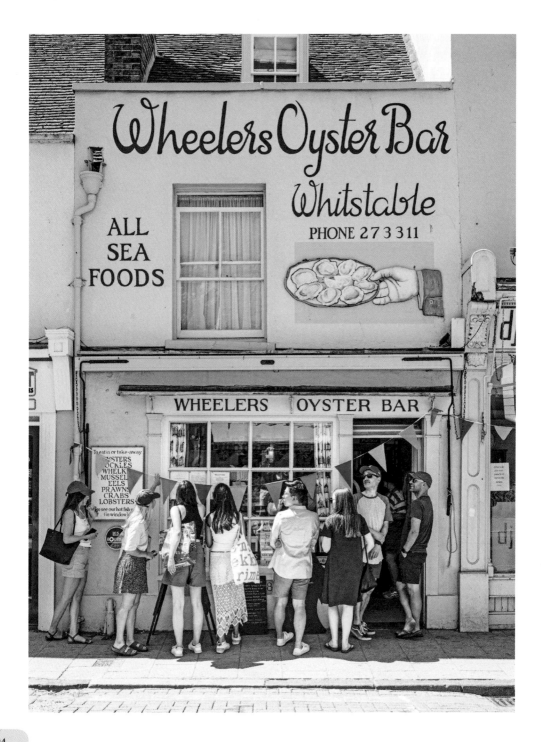

# Whitstable

## AN OYSTER LOVER'S DREAM

 1h 15m from London St Pancras or Victoria  🕐 12 hours

Whitstable is one of those places that you have definitely seen at least once on the 'gram and thought, 'Oh, my God, I need to go there!' And rightly so. A favourite seaside escape, its incredibly fresh seafood, beautiful coastal setting and vibe will put you in a good mood, no matter how stressed urbane life has become.

We always go with friends as it makes for a great day trip, catching up over oysters and white wine, while breathing in the salty sea air. The locals are also incredibly welcoming, a smile always on their faces that will make your visit to this quaint British seaside town even more special.

So, what's the main draw? Well, the oysters, of course. The famous native oysters are in season from September to April, when you will see oyster shacks and stalls all around town and the harbour, some of which offer to open the oysters for you. Kentish oysters have been famous since the Romans invaded Britain and realised how delicious they were. After trying them with a dash of Tabasco and lemon juice, we really do understand why. We tried the ones from the famous and super instagrammable Wheelers Oyster Bar (we are sure you have seen its pink façade before!) and we really couldn't recommend them more. They have a few tables inside, but we would suggest picking some up for takeaway and eating them by the seaside. If you want to do something more formal, maybe for dinner, you can head to The Whitstable Oyster Company, based in an old warehouse, with a terrace facing out to the estuary. It serves the most delicious fresh fish and seafood, which you can pair perfectly with some white wine or local beer.

You can also head to The Forge, a what-you-see-is-what-you-get shack, where they open oysters in front of your eyes. The Lobster Shack is great for something a little fancier. On the East Quay, it has amazing views and faces directly onto the sea.

However, you don't have to love oysters to love Whitstable. The harbour is oh so picturesque, with fishing boats coming and going and, on weekends, the open-air Harbour Market showcases locally created, British-made, handcrafted goods and fine art in around 40 little black huts. Talking of which, if you walk along the pebbled beach, you will see a number of colourful huts where people enjoy barbeques, picnics and relax by the sea. So idyllic, right? All this walking making you thirsty? Visit the iconic Old Neptune, one of the UK's few pubs literally situated on the beach, where you really must stop for a pint.

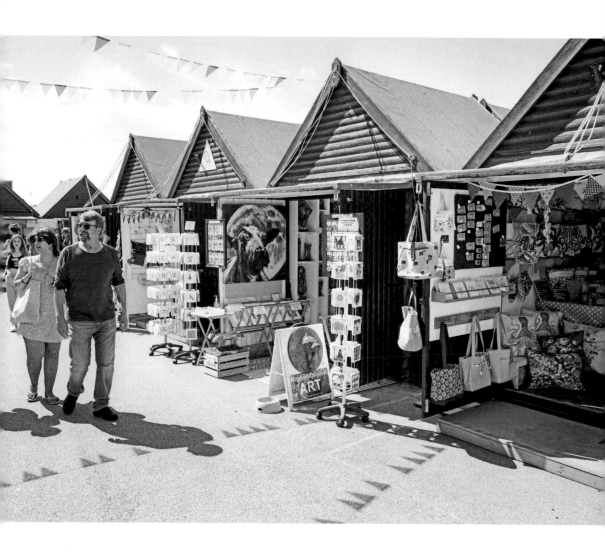

*If you and your friends are oyster enthusiasts, why*
*not let your trip coincide with The Whitstable Oyster*
*Festival? It usually falls in July or August, with stalls*
*and music all around town and even a parade on the*
*high street!*

# Margate

## A DIFFERENT SIDE OF MARGATE

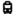 1h 30m from London St Pancras or Victoria ⊕ 24 hours

Ahh, Margate. Once considered a shabby seaside town and known to be unbearably busy during the summer months, it has become quite the cool kid in recent years. Culturally rich, with diverse eateries, Margate's always been a popular spot for Londoners wanting to escape the city. So hip that some call it Kent's 'Shoreditch on sea', we'll leave that for you to judge.

A mere hour and half from London and connected to Margate Station by Southeastern Railways, coastal town Margate makes for the perfect summer day, with its beach, indie cafés, inventive restaurants and independent boutiques. So, what's to do in Kent's capital of cool?

A town in transition, the old school charm of Margate is still there and clearly visible on the promenade along the seafront, with its candy floss stands, arcades and ice cream stalls, but there is definitely another side to discover. Margate is also quite big on the art factor. Did you know that JMW Turner painted his famous seascapes here? He first came to the town aged 11 and even went to school here. He believed the sunsets at Thanet 'the best in Europe'. The guesthouse at which he used to stay was at the back of the gallery named after him, Turner Contemporary. Head here for a free wander, immerse yourself in the impressive contemporary art collection – and spot those same views that Turner painted.

Still on the art theme we recommend the Shell Grotto, a Grade I-listed subterranean building, decorated with no less than 4.5 million shells. Its origins and actual purpose are a mystery, but we know that it was discovered in 1835 and has drawn visitors pretty much ever since. Some say it was possibly a smuggler's cave or a wealthy person's passion project, but who knows! It's one of Margate's hidden attractions.

While you are in the area, if you need coffee, we love the Scandinavian-inspired Mala Kaffe; they make the best flat white and banana bread. It's located in Margate's Harbour Arm, a stone pier where there are other restaurants and cafés.

If you want to stop for a drink, Fez is as eclectic as it can get. The Harbour Arms is a micropub located in a former fisherman's hut and faces the same landscape that Turner painted, while the BottleShop makes craft cocktails and has lovely sunset views from the upstairs snugs. But what's really exciting is the foodie scene! Head to Angela's for simple yet refined small plates and to try the catch of the day, or to Buoy & Oyster for really incredible platters of seafood overlooking the beach. Lastly, grab a drink and some street food at The Sun Deck to see the sunset. We also

love <u>Po' Boy</u> for Creole-inspired sandwiches and <u>The Bus Café</u> for a yummy brunch inside a vintage double-decker.

In the mood to shop? You'll be pleased with the many independent and vintage stores around. <u>Margaux</u> is notable for its gorgeous homewear, clothing and accessories. Grab a bottle of organic wine at <u>Urchin Wines</u> and rare vinyl at <u>Transmission Records</u> or at <u>Cliffs</u>, where you can also do your hair, get a coffee and do yoga all under the same roof. Our favourite though must be <u>Haeckels</u>, a gorgeous shop that sells soaps, skincare products and candles made from seaweed and wild local plants picked up along the coast.

If we have convinced you to extend your day trip and you want to stay the night there is no better place than <u>The Reading Rooms</u>, an Insta-worthy restored Georgian townhouse that'll make your eyes sparkle with joy. From roll top baths to the incredible in-room breakfasts on offer, we don't know what to love more.

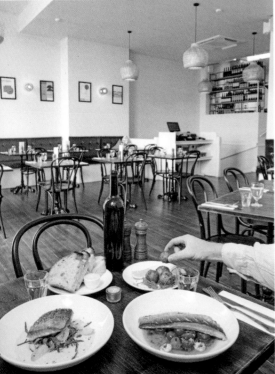

+ INSIDER TIP
〰〰〰〰

*Follow the coastal path from Margate and end up in Walpole Bay and if you dare to swim in the famous tidal pool, let us know how it is because we weren't brave enough! Then bring your swimwear with you and head to Kingsgate Bay to see the iconic white cliffs in the sheltered cove and take a dip in the sea. The nearby Botany Bay is very beautiful too, but it gets unpleasantly busy on hot days.*

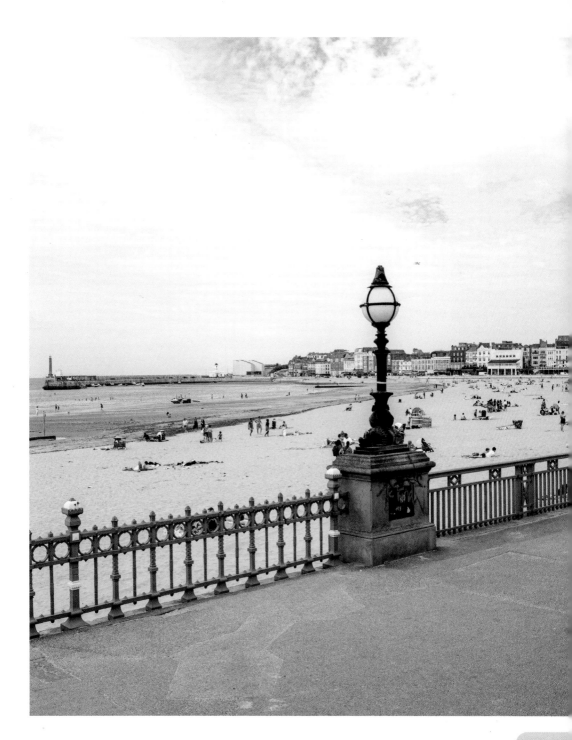

# Deal

Deal is one of Kent's most overlooked gems. It's smaller and less touristy than nearby Whitstable, not as busy as cooler Margate, and doesn't have the same historical importance of Canterbury, say. However, it's probably one of the most charming towns in this part of England.

During the 1700s, Deal was your typical British coastal town – the population spent most of their time building boats, sailing and fishing. These activities helped locals survive, but what really filled their pockets was smuggling. In Deal's town centre, in the middle of the picturesque, pastel-coloured houses and cobbled winding streets, smugglers used to evade King George's men and sell goods stolen by boatmen from ships. These clever smugglers also used secret tunnels to hide their goods, many of which are still hidden away today.

Nowadays, smuggling isn't Deal's deal anymore, but the fishermen's cottages and Georgian townhouses remain almost intact, so it feels like you're stepping back in time as you wander these picture-perfect streets!

On a sunny day, you will also want to take a stroll along the unspoiled pebbly beach, packed with colourful fishing boats, beach huts and waterfront bistros, which serve fresh, locally caught fish and seafood. Deal Pier Kitchen is a local's favourite, with its beautiful beach views (you are literally surrounded by water), while if you are looking for a little more elevated cuisine you can always head to The Rose, with its beautiful terrace – or Frog and Scot, handily situated opposite.

For history enthusiasts, there is also a beautiful Tudor artillery castle, built by Henry VIII as part of a chain of fortifications to defend the coast from the French (you can even see the French coast, a mere 25 miles away, on a clear day).

Deal is great for shopping. It has some amazing markets, so before heading there for your day trip, make sure to check out what's on. On the first Saturday of each month, you can load up on locally picked fruit and baked cakes from the Farmers' Market, while on weekends there is The Village Indoor Market, where you will be able to shop antiques, crafts and vintage fashion items.

+ MAKE THE STAY LONGER

*If you want to make a weekend of it, the 200-year-old The Rose, with its moody interior and lush rooms, makes for a romantic, yet centrally located venue.*

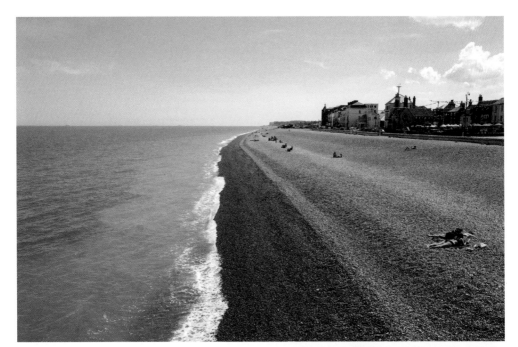

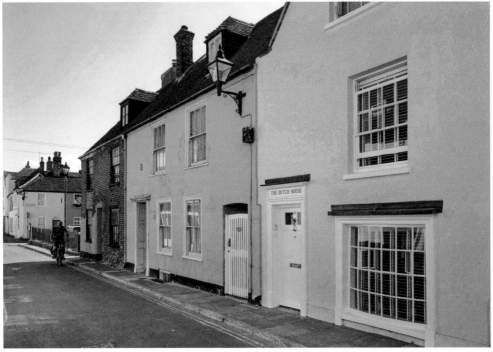

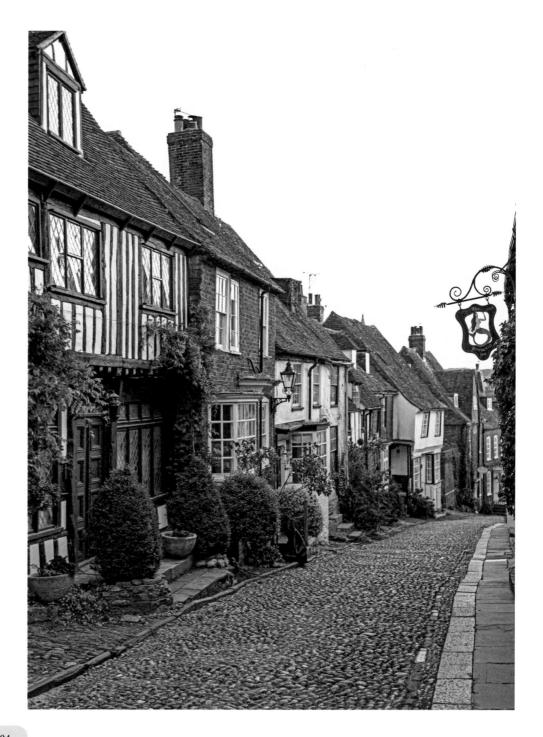

# Rye

## A PICTURE-PERFECT CINQUE PORT

 1h 15m from London St Pancras ⏲ 12 hours

A visit to Rye in East Sussex is one of those day trips you must do at least once as a Londoner. This perfectly preserved medieval town, nestled between green rolling hills and the English Channel, is packed with cobbled lanes, crooked houses and ancient inns. It's survived marauders, smugglers and a fire that almost brought it to its knees in the fourteenth century. Now it draws tourists from around the world to walk its ancient streets, view its galleries, shop its vintage shops and markets, visit <u>Henry James and E.F. Benson's Lamb House</u> or imbibe or eat at one of the many pubs and restaurants.

Back in the day, Rye was mostly surrounded by water, to the point that at high tide it was almost an island. Once one of the south-east's most important ports, as one of the Cinque Ports, and popular with smugglers, it now lies two miles inland from the sea.

You may have been drawn to Rye though because of a picture-perfect image of quaint <u>Mermaid Street</u> on the 'gram – and this is where we recommend starting your trip. Here, you will find a mixture of timber-framed inns and houses, many of which you can visit as they have been transformed into restaurants, pubs or tearooms. Smugglers used to hide their goods and gather to tell their tales. Ah, if only those walls could talk!

A stop at the <u>Mermaid Inn</u> is a must, even just for lunch or a drink at the famous Giant's Fireplace Bar. This 600-year-old inn is packed with charm and history and has 31 unique rooms, if you want to turn your day trip into a weekend.

Another alternative is <u>The George</u>, on the High Street, which dates back to the sixteenth century, where you can enjoy a relaxing drink or afternoon tea. The <u>High Street</u> is packed with bookshops, quirky independent shops and antiques, in addition to art and photographic galleries. We can guarantee that it will be impossible not to bring something back to London! Also worth doing while you are here is climbing the bell tower at the twelfth-century <u>St Mary's Church</u>, which has views across Rye's colourful rooftops.

Feeling hungry after climbing the tower? Head to one of the many restaurants that serve seafood. It's fresh and a lot cheaper than London!

+ MAKE THE STAY LONGER

*Fallen in love with Rye and want to make a weekend of it? Why not stay in Rye's windmill! This Grade II-listed building makes for a unique experience, but be sure to book one of the two suites as they are the only rooms that are actually inside!*

# Camber Sands

## A GOLDEN DELIGHT

🚗 2h by car  🕐 12 hours

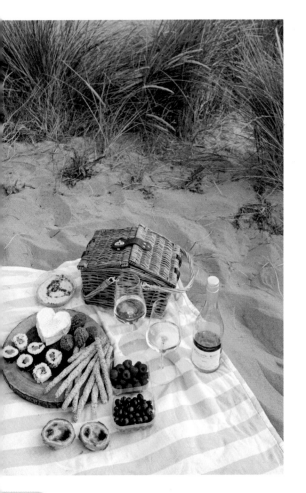

Camber Sand's dunes of fine gold have always been a favourite among London daytrippers craving the beach. Most UK coastlines are made up of pebbles, so if you prefer soft sand, you'll love this trip. Located near pretty Rye, in East Sussex, it's quite easy to reach. If you don't drive, just hop on the train to Rye and then take the 102 Wave bus to the beachfront.

The beach stretches for miles, five to be precise, and it has that wild and unspoilt feel that people love. So there is space for everyone, even on those very hot days in the UK, when everyone wants to be by the sea. The best part of Camber Sands, in our opinion, is the west side, where the River Rother connects to the sea – the other end is more shingle – so definitely head towards that area.

During the winter months, this beach is dog-friendly, making it a good excuse for a winter day trip too. You'll probably have the beach to yourself, and as the sun sets early in winter, you can enjoy this view. In case you are thinking of bringing your dog during summer though, be mindful as from May to September there are restricted areas and zones where you have to keep your dog on a lead. We do think Camber Sands is especially beautiful at sunset, though, when you have that glimmering golden light reflecting on the sand and the water. It makes the perfect setting for a lovely picnic, so bring your hamper, snacks and a chilled bottle of rosé and you can enjoy the most romantic evening among the sandy dunes.

+ INSIDER TIP

*Once you are there why not visit Hastings? It is only a 30-minute drive away and is a lively seaside town. We love strolling along the promenade and the award-winning pier, ice cream in hand, looking at the view, all the way down to Beachy Head.*

# Beachy Head

## CLIFFS AND LIGHTHOUSES

🚗 2h 45m by car; 🕐 24 hours

Looking to shake off the stress of the city? There's no better place than the spectacular chalk cliffs of England's coastline to recharge your batteries. In case you didn't know, they were formed over 66 million years ago and the chalks emerged during the Ice Age when the coast was gradually pushed up by the sea. The increasing sea levels cut into the chalk to form the English Channel and the beautiful rugged coastline that we all know. These strikingly white cliffs make up the shoreline of Eastbourne and they stretch for miles on towards Seaford, to reach the Seven Sisters. Beachy Head is actually the highest and most spectacular point on the coast, reaching some 162 metres (530 feet) above the sea. There are several tracks that connect Beachy Head to the Seven Sisters and the South Downs, and they are very scenic paths, so bring your most comfortable shoes if you want to go for a longer walk (and we recommend that you do). Beachy Head is also wheelchair-friendly, via the Peace Walk.

Once you have taken in all the views of the English Channel from Beachy Head's high cliff, we suggest walking west towards Belle Tout Lighthouse. Built in 1831, it was decommissioned in 1902 and has survived war, rebuilding and a reincarnation as tearooms and a pretty guesthouse! With 360-degree views of the sea

and themed rooms such as 'Keeper's Loft' and 'Captains Cabin', this is one of the most unique stays you will ever have.

To get back to where you started, retrace your footsteps: the whole round trip should be about two miles. We particularly love the views coming back to reach Beachy Head as they offer such a unique perspective over the cliffs. The most iconic shot though is courtesy of the <u>Beachy Head Lighthouse</u>, with its red and white stripes contrasting with the landscape beyond. This pretty lighthouse was built out in the water and is truly unique. Definitely get your camera ready!

+ INSIDER TRIP

*Beachy Head remains quite unspoiled, so facilities tend to be lacking. Bring water and snacks and remember the public toilet is a ten-minute walk from Beachy Head West Car Park.*

C
O
A
S
T

# Cuckmere Haven

## ONE OF THE BEST LOVED VIEWS IN BRITAIN

 2h 15m by car  🕐 12 hours

Cuckmere Haven, in East Sussex, is a place of tranquillity and the ideal locale to switch off from the congestion of daily life in London. Sitting where the meandering Cuckmere River meets the English Channel, it has incredible views over the chalk-cliffed coastline, picturesque panorama and quiet pebble beaches. Compared to other coastal beauty spots, Cuckmere is relatively quiet; it's also well protected from the wind, so if you decide to pack your picnic basket and head here on a summer day, we won't blame you.

Like most coastal locations in the south of England, Cuckmere Haven played a key role in the smuggling trade. Two hundred years ago, the black market thrived, as high taxes on everyday goods left many in poverty, forcing them to find alternative ways to make money and to obtain goods. The area used to be quite busy and chaotic, the complete opposite to today, when not much can be heard apart from the sound of the waves and the call of the many different types of birds that gather here.

The proximity to the Seven Sisters, the cliffs that attract many artists and photographers, is a draw, and the best spot can be found looking out from the Coastguard Cottages towards the cliffs. These cottages have been watching over the bay for several hundred years, its inhabitants carrying out lifesaving duties, combating smuggling and guarding against invasions during the two World Wars. This angle has become one of Britain's most-loved views, so it's no wonder it has been used so often as a film location – *Harry Potter and the Goblet of Fire* and *Robin Hood*, are among the most popular.

+ INSIDER TIP

*If you want to head for a picnic on the beach with beautiful views over the cliffs, you should park your car at the Seven Sisters Car Park and walk the trail (approximately a 30-minute walk). If instead you want the famous Coastguard Cottages shot, put Seaford Head Nature Reserve into Google Maps and you will be able to park your car and walk to the viewpoint. Also, if you are heading to the beach, you won't find any restaurants there, so it's a good idea to pack some food and drinks for the day. You may end up having one of the best and most picturesque picnics of your life!*

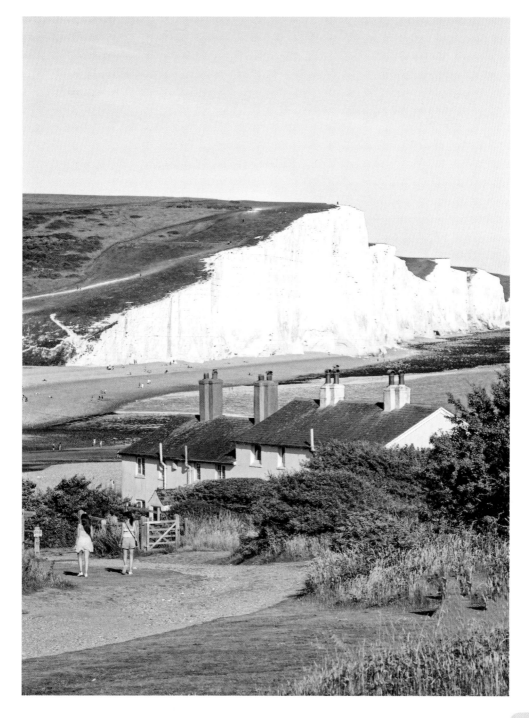

# Bosham

## A LANDSCAPE
## PHOTOGRAPHER'S DREAM

 2h from London Bridge 🕐 12 hours

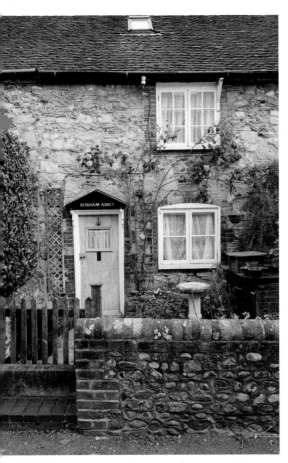

*Bosham is full of picture perfect streets and cottages.*

Bosham (pronounced 'Bozzum') is one of the most picturesque villages you will see in England, where photographers and artists often head to witness stunning sunsets along the pretty southern coastline. This small town in West Sussex is great for a summer day trip from London – or it's the perfect pit stop if you happen to be driving by the area, as it's easily reachable from the motorway, and not far from Chichester.

The best part of this town is probably vibrant Bosham Quay, which gets very popular during the warmer months, and there are many boats and yachts moored offshore. This creates the perfect atmosphere for a quaint walk along the coast, watching people sailing and paddleboarding (or you can also try it yourself) while waiting for the sun to set. People-watching isn't the only thing you can do though. As the strong tides attract many different bird species, keep your eyes peeled! There are lots of little pubs and foodie spots to linger at, with the most popular probably being the Anchor Bleu, which has panoramic views over the water.

Bosham Walk is also really worth a visit while you are there as you will find many arts and crafts shops, with unique pieces to bring home to remind you of this picturesque day trip.

+ INSIDER TIP
〰〰〰〰〰〰

*Beware of the tide! No, really. If you head to the
Anchor Bleu pub, you can see what happens to
cars that park in the wrong spot in some of the
photographs on the wall. Although the photos are
quite funny, you would probably find them less
entertaining if you found your car floating around
the Quay!*

# The Pig – On the Beach

### JURASSIC VIEWS AND A DORSET KITCHEN GARDEN

🚗 3h by car 🕐 24 hours

*The hotel is the perfect escape from busy London life!*

We don't know what to love more about this cute country–coastal hotel. The first thing that comes to our mind though is the location. As the name hints, The Pig – on the Beach is situated in the most idyllic setting along Studland Bay, so close to Dorset's sandy beaches and to that famous coastline's cliffs. Durdle Door and Lulworth Cove are just a half hour car trip if you want to venture into Dorset's World Heritage coast, and the white chalk headlands of Old Harry's Rocks are so close that you can see them perfectly from the hotel's gardens, while sipping at one of The Pig's delicious cocktails.

In case you don't know, The Pig – on the Beach is part of a much-loved collection of eight other Pig 'restaurants with rooms', as they like to call themselves, all relaxed, with a rustic vibe, but all also very much curated in every detail.

This branch of The Pig is one of the most unique, with its mellow, yellow manor, which you'll adore from the second you arrive. With all its turrets, it does look a little like it's out of Hansel and Gretel! Inside, there are no scary witches though, but instead the design is shabby chic galore, with the perfect balance of luxury and comfort to make you feel at home. It's got that quirky vibe of 'we just threw a few things together' that works oh-so-perfectly.

*Enjoy a stunning view from each room, whether it is the rippling blue sea or the luscious kitchen garden.*

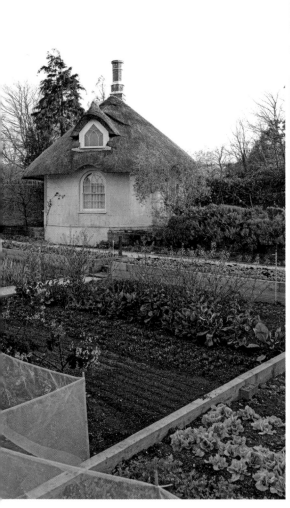

+ INSIDER TIP

Don't miss out on a treatment in the Sheep Huts. Located a bit
further afield, between actual roaming sheep, we recommend a
revitalising sugar scrub or seaweed facial in one of the two private
treatment huts. Be sure to book in advance to secure a spot.

Outside there's a beautiful lawn where you can soak in the sun on the loungers looking at uninterrupted views over the white cliffs, snack on an oven-fired flatbread or enjoy a sunset dinner during the summer months.

Our favourite feature – and true heart of the hotel – is the walled kitchen garden. Perfectly manicured, it'll make you want one of your own, even if you live in a central London flat. Here, you can find plenty of herbs, salads and vegetables, all used of course in the beautiful Conservatory restaurant which, with its rusting wooden tables, vintage cutlery and ceramic pots of herbs, blends in with the atmosphere perfectly. Local or homegrown are key words in the chef's kitchen. For everything they can't source in house, The Pig is very proud of the signature 25-mile radius menu, meaning that every product on the menu is sourced or foraged (they even have a dedicated chef for that) within that perimeter. Salads and herbs from the walled gardens, local seafood and products means that the menu changes every day, depending on what the forager finds and what the kitchen garden team deems to be in perfect condition. For breakfast, we are obsessed with their eggs (we go to The Pig for those alone), but their perfectly arranged table spread with seasonal fruits, local cheeses and handmade banana breads is really worth mentioning.

In terms of rooms, be sure to ask for one with a sea view: it's so soothing to wake up to the blue glimmering in the distance. If you are looking for a more secluded hideaway, book the Bothy and the Lookout, two thatched 'cottages' overlooking the kitchen garden, or for a glamping experience Harry's Hut and The Pig Hut in the hotel grounds. Both are very romantic!

Of course, a stay at this Pig is not complete without a trip to the beach, so follow the path down to the sandy coast and dip your toes in the fresh waters of Studland Bay. While you walk the path, you'll stumble across Fort Henry, the World War II concrete-bunker where Winston Churchill, King George VI and Dwight D. Eisenhower watched the troops preparing for D-Day.

All in all, after a couple of days at The Pig, you'll leave perfectly recharged – and you'll want to come back from the second you depart.

# Five Best Vineyards

England might not be massively famous for its wines, but in recent years its sparkling wine has been picking up more and more awards, so what better than to spend a day with friends at a lovely vineyard? The best time to go is in September or October during the harvesting season, when you can see the whole process of how the wines are made. And, of course, taste one or two.

**1. LYMPSTONE MANOR** *Devon*
A beautiful, luxury, Grade II-listed Georgian country house hotel in the heart of Devon. The vineyard is a passion project of popular Michelin star chef–patron Michael Caines and he planted 17,500 vines here in 2018. The first harvest was in 2022, and if you are not a guest you can book special lunch packages with vineyard tours from May to September.

**2. GREYFRIARS VINEYARD** *Surrey Hills*
In the Surrey Hills, just outside Guildford, this award-winning vineyard is probably the closest to London. Visit for their seasonal tours and tastings and other events, which include pasta-making and yoga, all with award-winning wine tasting, of course.

**3. DENBIES WINE ESTATE** *Surrey Hills*
Denbies Wine Estate can also be found in the Surrey Hills and has an on-site hotel, meaning you can stay and wake up with a wonderful vineyard view. You can enjoy fine dining care of their beautiful restaurants, with dishes paired with the wine from the estate.

**4. BOLNEY WINE ESTATE** *South Downs*
Based in Sussex, on the edge of the South Downs, this is one of the oldest vineyards in the UK, having first opened its doors in 1972. Book one of their tours to discover the journey from vine to award-winning wine, and don't forget to take advantage of the cheese and wine tasting experience too.

**5. NYETIMBER ESTATE** *South Downs*
Visiting the stunning Nyetimber Estate, with views of the South Downs, is such an experience as you will see some of the oldest vines in England, and can enjoy a wine tasting or haute cuisine hosted in the fifteenth-century Medieval Barn. But keep an eye out for their open day tickets as they sell out fast.

*Opposite: Greyfriars vineyard is a short journey from London.*

# Jurassic Coast

## 95 MILES OF NATURAL, HISTORIC BEAUTY

🚗 3h by car  🕐 12 hours

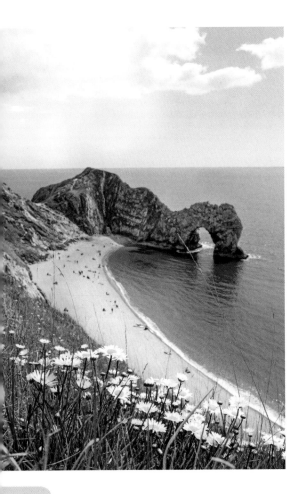

The majestic Jurassic Coast stretches 95 miles from Orcombe Point in Exmouth, Devon, to Old Harry Rocks in Dorset, and is one of those locations you must visit at least once in your life. It's England's only natural UNESCO World Heritage Site and it makes for the perfect summer excursion, with its unique geology, incredible rock formations and great walking trails. There is so much to see within those 95 miles that you will probably want to visit more than once or make it a weekend away. Before getting into our recommendations, a little bit of information on why the Jurassic Coast is so special.

When walking along the sandy beaches or hiking on one of the many trails, you will probably be standing right on top of fossils of giant marine reptiles and dinosaurs. Why? Because just beneath your feet there are some 185-million years of our planet's history. The rocks, landforms and fossils here reveal how the Earth has changed and evolved, as each era brought drastic changes to how the coast looked. At different times, the coast has been a desert, a tropical sea, a forest and a marsh, with fossilised remains of the creatures which lived there preserved in its rocks. Now that you know this, we can hear you turning your engine on to head

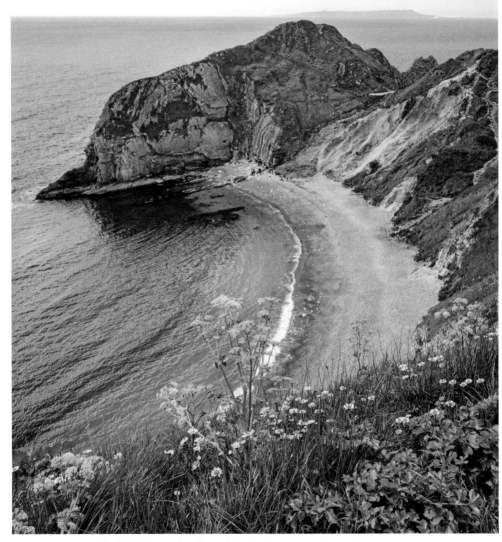

*The picturesque coastline is full of caves, beaches and luscious forests to explore.*

to the coast. But before you do that, let us give you some tips on where to go, as there is a lot to see!

The most iconic spot on the Jurassic Coast is probably Durdle Door [1], a natural arch formed from a layer of limestone standing vertically over the sea. In addition to being picture-perfect and one of Dorset's most photographed sites, its pebbly and sandy beaches are pretty popular during the hottest days of summer and can get really busy, too. You can reach them on foot by walking down a path, but we would definitely recommend walking boots or trainers as it's very steep. Also, pack some lunch as there aren't any restaurants or cafés there, only breathtaking nature.

If you feel like doing a little hike and checking out some other beautiful viewpoints, you can either head right (facing the sea) and walk 15 minutes towards Scratchy Bottom [2] for an incredible view over Durdle Door on one side and over some white chalk cliffs on the other, or head left towards popular Lulworth Cove [3]. This location – which is a 30-minutes walk from Durdle Door – is one of the most picturesque spots on the Jurassic Coast and probably one of the best examples of cove formation in the world. A short walk away there is also Fossil Forest [4], with tree stumps fossilised in the rocks.

If you still have time and want to add one last stop to your day trip before heading back to London, go to Old Harry Rocks [5], a half-an-hour drive from Durdle Door. These spectacular chalk formations are the perfect spot for sunset and attract many photographers. The name Old Harry actually only refers to the stack of chalk standing furthest out to sea. Did you know that Old Harry had a wife?

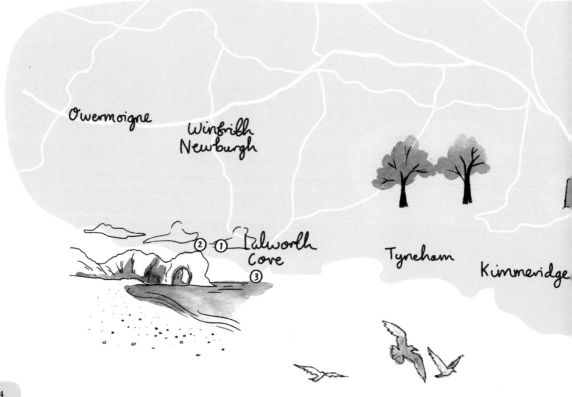

Indeed, there was another stack of chalk called Old Harry's Wife, but in 1896 erosion caused her to tumble into the sea.

As mentioned, you will probably want to go to the Jurassic Coast more than once as there is so much to see and do. You could head to the coastal towns of Lyme Regis or Charmouth for some fossil hunting and walking trails, or to Chapman's Pool for beautiful landscapes and West Bay for some unique golden cliffs. Also find the time to head to Castle Corfe [6], an idyllic little village that features a magnificent castle located up a hill. It provides the most stunning picture backdrop. In addition to being ancient (the village was built in the early twelfth century), it has pubs and restaurants and is perfect for a lunch break.

+ MAKE THE STAY LONGER
wwwww

*Turning this into a weekend – or even longer – could be a good idea if you want to explore the whole 95 miles of coast, enjoy some good seafood and do a few walking trails. During our last visit, we stayed at the wonderful The Pig – on the Beach (see pages 116–119) before heading to Cornwall (see pages 126–131), which could be a great idea if you are planning a week or so away and want to visit more locations along the British coast!*

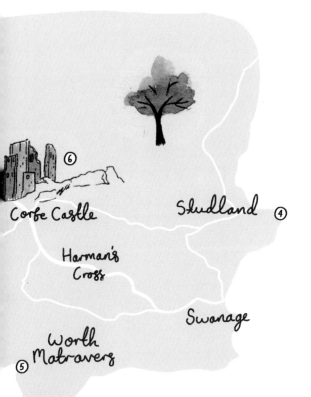

Corfe Castle (6)

Studland (4)

Harman's Cross

Swanage

(5) Worth Matravers

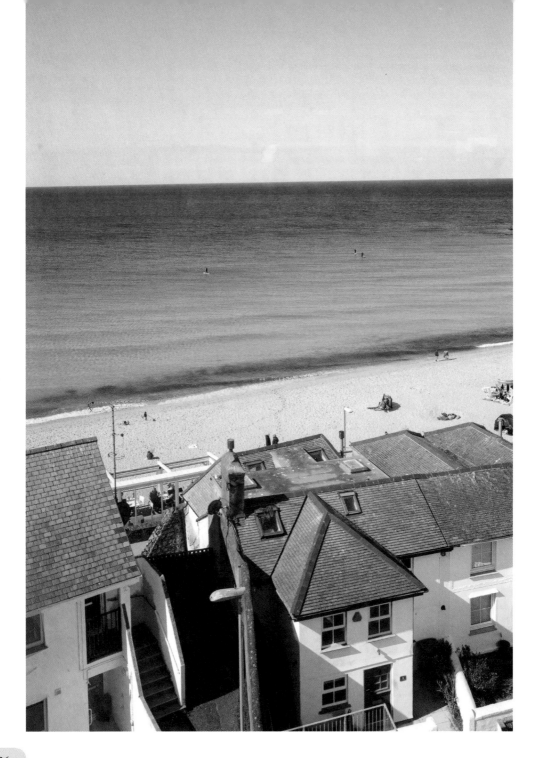

# Cornwall

## GETTING ON THAT CULTURAL WAVE

🚗 5h by car  🕐 48 hours;

Cornwall, on the south-west tip of England, is possibly the most loved summer destination in the UK. With its beautiful, rugged scenery, Mediterranean-like clear blue waters, culture and history, it is not hard to understand why. That, and there's the fresh seafood and surfing!

There is a lot to see in Cornwall and not everything will fit into your weekend trip, but we have made a round-up here of our absolute favourite places to visit and things to do in the south of the county. Soaking up the surfing vibe – and trying it yourself – is a must, but also getting immersed in the artsy landscape that this region has to offer should definitely be on your cards. If travelling by train or plane, we recommend hiring a car on your arrival so that you can make the most of your time here. August is definitely the busiest month, prices sky rocketing and the little roads packed with impatient drivers. May is a great time to visit for good deals in hotels; the beaches are quieter after the Easter rush, plus the weather can offer some really nice surprises. September and October are great for surfing and the water is at its warmest after the summer.

For your stay, we found the perfect base from which to explore, the stunning Watergate Bay Hotel in Newquay. Its dreamy Beach Lofts are very design-centred, with floor to ceiling windows, and

featuring unique artworks by local artists. As the name suggests, they are right by the beach and connected to the sand by a private passage. . . imagine rolling out of bed and straight into the sea for your first surfing lesson of the day! We did just that for two days straight and absolutely loved it. For a sunset dinner, head to the adjacent Beach Hut and order the Cornish crab bucatini – you'll thank us later! It's the perfect base from which to explore our favourite places, which are all a short drive away.

Touring any of the pretty villages in Cornwall, it's hard not to stumble across one of the many art galleries that populate their narrow streets and impossible not to come across local artists painting landscapes and presenting their art to visitors. This is especially evident in St Ives, just an hour's drive from Watergate Bay Hotel, where the artistic presence from past and present is really strong.

This picture-perfect fishing village, situated on the Celtic Sea, has always been buzzing with artists who are inspired by the beautiful Cornish landscape. Turner arrived in St Ives in 1811 to capture a mystical pink light that sometimes shines in the village, starting a pilgrimage by artists aiming to catch that very same thing, and positioning St Ives as the influential art hot spot that it still is today. It was so important that the iconic Tate decided to open a museum right there, in honour of the famous painter, and to showcase local artists.

Definitely go inside the Tate St Ives to catch one of the ever-changing exhibitions and to enjoy the view from the café over the Atlantic Ocean. Perhaps take one of the many painting or sculpting classes available, and after you have wandered around the idyllic harbour and got lost in the cobbled streets, the only thing left to do is visit the Barbara Hepworth Museum and Sculpture Garden.

You can combine tickets with the Tate and visit this internationally renowned sculptor's residence to see her bronze works, inspired by the landscape of St Ives. Before heading to nearby Penzance, you can't miss a trip to the unique castle of St

Michael's Mount and a stroll through its exotic gardens. Depending on the tide, you'll need either to take a short boat trip or a walk through the causeway. Stop for lunch at Mackerel Sky Seafood Bar, a popular little restaurant with incredible fresh scallops and crab nachos, to refuel and really taste simple but delicious seafood.

Next stop is the must-see Minack Theatre, so get your tickets online and pack wind-appropriate clothes (trust us). We are sure this cliff-perched open air theatre will leave you speechless! In the summer evenings, there are live performances but reserve your tickets in advance as they usually sell out.

We are sure these few days of breathing in the fresh seaside breeze, eating great seafood and exploring cultural Cornwall are just what you need to relax and feel like you are miles away from your busy lives. Hopefully you'll also pick up a trick or two in your surfing lessons, ready for your visit next year!

+ INSIDER TIP
〰〰〰〰〰

*Before leaving Cornwall, head to the curious Eden Project,
an educational charity and landmark attraction built on a
former clay mine, developed around a series of massive
domes, or Biomes as they call them. Here you'll find the
world's largest indoor rainforest and rare and interesting
plants and microclimates. It makes for the perfect ending
to your weekend in this unique county.*

C
O
A
S
T

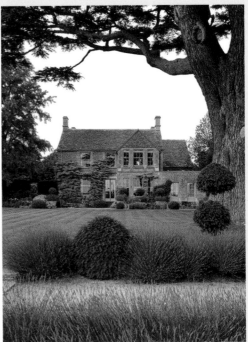

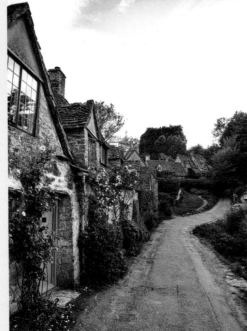

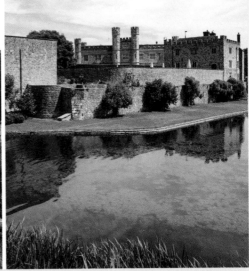

# COUNTRYSIDE

---

COUNTRY ESCAPE. All this land. Rolling hills. Golden fields. *London seems afar.* Village pub. Cottage vibes. Oh, a lamb! MANOR HOUSE. *Look at that.* Chirping birds. Rolling hills, local gins. COTSWOLDS. *Slow life.* River streams, wooden beams. All the cows. Stately homes. *National Trust.* Lavender dreams. NEW FOREST. Surrey Hills. Don't want to leave.

Cornwall

Blackpool

Henry Moore Institute

York

Manchester

Snowdonia

IRON BRIDGE

Stoke-on-Trent

SHEFFIELD

NOTTINGHAM

Norwich

Southwold

Birmingham

① ⑤ Stratford-upon-Avon

② OXFORD ⑧

Cambridge

③ Cardiff ④ ⑥

⑦ ⑪ LONDON

⑬ STONEHENGE ⑫ ⑭

⑯ NEW FOREST ⑱ ⑳

⑩ ⑨ ⑮ BRIGHTON PALACE THEATRE ⑰ ⑲

Brighton ⑯ ⑰

DOVER

# Hampton Manor

## AN ESCAPE FOR FOODIES

 2h from London Euston 🕐 36 hours

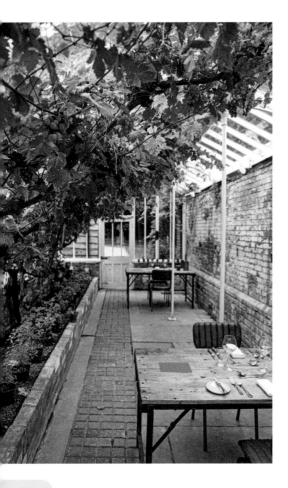

Hampton Manor, a family-owned hotel in Arden, near Birmingham, offers a foodie experience like no other. Frederick Peel, son of Prime Minister Robert Peel, was responsible for building the Gothic manor in 1855. The hotel now champions organic food, wines and farming. Hampton offers a two-night stay package that takes its guests through a gastronomical journey, where dinner at their restaurants is included, together with breakfast and a wine tasting.

The nineteenth-century manor and its grounds are stunning, not something you would expect in this part of England. The bedrooms are decorated with William Morris wallpaper and have a mix of antique and modern furniture. Think beds with statement headboards, old school armchairs, bookshelves and in-room bathtubs, all with earthy tones. Art is abundant in the hotel, but while places like this can be very intimidating at times, Hampton Manor is very laidback and fun, mostly thanks to its young, knowledgeable and friendly staff, who really make you feel at ease.

Now that we've sold you the interiors, let's talk about the best part, the food. The Hill family, who own the Manor, really have thought about everything when it comes to taking you on a

perfect gastronomic journey. The Peel restaurant – which has held a Michelin star since 2016 – serves perfectly presented dishes, using vegetables from the garden and local and sustainable produce. The dishes are very generous and the wine is sourced from small producers across England and Europe, meaning you will be trying wines you will probably not see anywhere else. The staff are very enthusiastic and will tell you everything about the dishes and their ingredients, which isn't something you get everywhere.

Our favourite restaurant, though, has to be The Smoke, which is set near the Victorian walled garden, with some tables located inside the greenhouse, where you can even pick your own tomatoes and eat them directly from the vine! If you still have space after dinner, you can sit by the fire next to the greenhouse and toast some marshmallows, before heading to the whisky bar where the expert bartenders will tell you everything you want to know about the spirit. Even at the bar, the atmosphere is very relaxed, with people sipping G&Ts, playing pool and switching vinyl records.

+ INSIDER TIP
〰〰〰〰

*Why not complete your experience with an afternoon tea? It is served in the hotel's beautiful parlour and it's as delicious as the rest of the food. Be sure to make time to relax on the deckchairs overlooking the grounds while sipping some English sparkling wine. Truly blissful.*

# Blenheim Palace

SOMETHING TO DO FOR EVERY SEASON

🚗 2h by car  🕐 12 hours

One thing the UK doesn't lack is beautiful country houses and stately homes to explore. Surely, though, Blenheim Palace in Oxfordshire is one of the most impressive you can visit on a day trip from London?

The only non-royal and non-episcopal country house in England to retain the title of palace, it is actually a UNESCO World Heritage Site, too. Presented to John Churchill, first Duke of Marlborough, in the 1700s, it was the birth place and home of great statesman Sir Winston Churchill. On your visit you can even see the tiny room where he was born on 30 November 1874 and retrace his steps by following his favourite pathways and visiting his cherished places in the immense gardens. You can actually spot the Temple of Diana, where Churchill famously proposed to his soon-to-be wife. Talking of gardens, you are in for a treat. Visiting the spectacular Formal Gardens and the Park, set in-between lakes and incredible trees, will make you feel like you are in a fairy-tale. Put on your best floaty dress and be ready to take some pictures!

*Opposite: Blenheim Palace is renowned for its impressive gardens.*

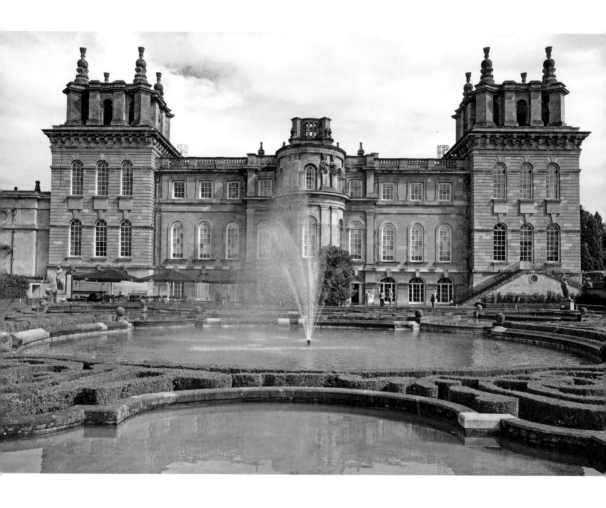

+ INSIDER TIP
~~~~~~~~

There are many incredible events happening at Blenheim Palace. Head there at the end of June for Blenheim Palace Flower Show, when the gardens are transformed, and the end of October for the 'spooky' Halloween Trail through the woods. Our favourite, though, must be the Christmas trail – mid-November to January – truly a magical experience when each State Room is transformed into a Christmas fairy-tale. Lighting trails and tunnels make the gardens dazzling.

Among magical trees, stone bridges and passing swans, Blenheim Palace really looks picture-perfect. To make your life easier and to make sure you see everything, we definitely recommend taking a buggy tour through all the incredible flora and fauna, wildlife and picturesque landscapes of the estate.

If you are in the mood to walk and have a bit more time, go for one of the walking trails – you'll feel like you are in your own countryside estate! Also, don't miss the free one-hour tour of the Formal Gardens, the more refined gardens surrounding the palace, and immerse yourself in the Duke's private Italian garden, smell the roses in the Rose Garden and relax by the water features. It is truly magical!

If you manage to make your way inside the palace, take a tour of the State Rooms in all their glory, and soak up the glamour and style of the incredible tapestries, ornaments and furniture. For the curious types, like us, there is also an 'Upstairs' tour of the Marlborough family's private apartments and a 'Downstairs' tour, where you can hear all the gossip about the palace staff's lives and operations. We cannot guarantee that there are no ghosts about, but it's worth the risk! Now, what better way to finish your visit than with an elegant afternoon tea? Head to the sunny Orangery for a quintessentially British treat.

Above: Enjoy an exquisite afternoon tea at the Orangery. *Below:* It's well worth taking a tour of the grand state rooms.

The Painswick

🚗 2h 30m by car 🕐 24 hours

Painswick for us is one of the best-kept secrets of the Cotswolds. It's not as touristy as Castle Combe, Bibury and Broadway, and less busy than Bourton-on-the-Water and Burford. It's a little oasis of tranquillity packed with tiny streets, traditional pubs and quirky unique shops. The main attraction of Painswick is the 99 yew trees surrounding St Mary's Church. These were planted in 1792 and dominate the churchyard, making it just so charming. Why 99 though? Legend has it that tree number 100 can never grow here as it would be pulled out by the devil. Crazy, right? Maybe . . . We always come to this pretty village – also called the 'Queen of the Cotswolds' for its beauty – when we fancy a peaceful walk, with a stop at The Painswick hotel a must.

The Painswick is a beautiful honey-coloured boutique hotel set in an eighteenth-century building, with 16 chic bedrooms all filled with art and antiques and distinguishably different from one another. It has beautiful views over the rolling hills of the Painswick Valley and is perfect for a romantic weekend away. The atmosphere is very relaxed and in line with the rest of the town, but not so relaxed that it's boring. There is a games room with a pool table and board games, plus an outside space where you can drink a G&T or

two when the sun is shining. Also, the hotel has put together some fantastic interactive walking trail maps, which means you can pop on your wellington boots and head for a walk in the hills without getting lost. Our favourite trail is the one that leads to the alpacas and horses just down the hill next to the hotel; you can ask the friendly staff and we are sure they will be happy to tell you which one it is!

Like most boutique hotels in the Cotswolds, the meals at The Painswick are a big part of the pleasure of staying there. The restaurant is exceptional, with seasonal food that changes frequently, all beautifully presented and in a smart-casual setting. Breakfast is also delicious and abundant, and if you can get a table on the balcony on the first floor, you will feel as if you are in Tuscany (minus the weather, most probably!). If you still want to experience the food at The Painswick but are only there for the day, definitely try the champagne afternoon tea: the scones are to die for.

+ INSIDER TIP

If you are visiting Painswick, the Painswick Rococo Gardens are an absolute must. They are only a five-minute drive away and contain plants from all over the world, a nursery, a kitchen garden and a maze. Visit in early spring to see carpets of snowdrops – the perfect backdrop for your next photo on the 'gram.

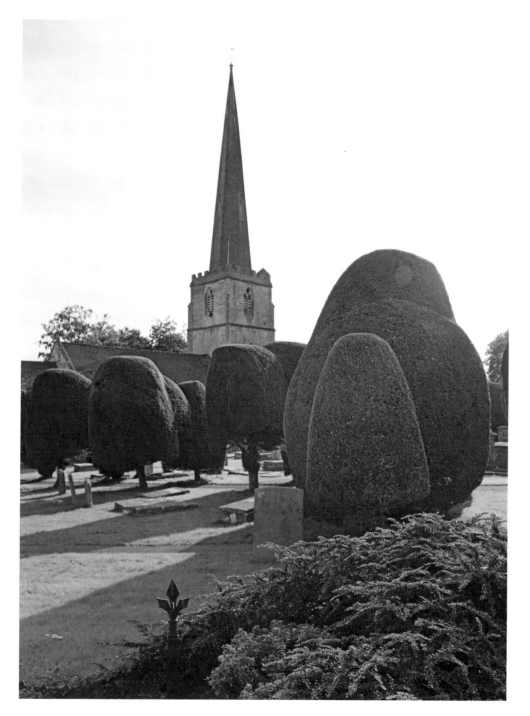

Barnsley House

ALL ABOUT THE GARDEN

 2h by car ⏱ 36 hours

Barnsley House is the type of country house retreat that people dream about. This seventeenth-century manor house nestled in beautiful fairy-tale gardens boasts one of the best spas in Gloucestershire and has idyllic Cotswold scenery and rolling hills all around. It's a pretty special place and definitely one to keep in mind if you are planning a romantic weekend, as it's one of the few adults-only hotels in the Cotswolds.

So, what makes Barnsley House so different? The answer – its wonderful gardens. The beautifully landscaped grounds were designed by the renowned Rosemary Verey, who lived in the house for almost 50 years. Verey also designed Elton John's and the King's Highgrove gardens! There are four acres full of vegetables, fruit and flowers, carefully chosen so that there is something special and unique during every season, making it literally impossible to choose when to visit this hotel. Our favourite season has to be spring as we are suckers for wisteria and Barnsley House is covered in it, plus you will find one of the most admired and iconic features in full bloom, the Laburnum Walk. Created by Verey in 1964, using trees received as a silver wedding anniversary gift, this fragrant, yellow-flowered tunnel alone is reason enough to visit the gardens on a late spring day. The talented gardeners who

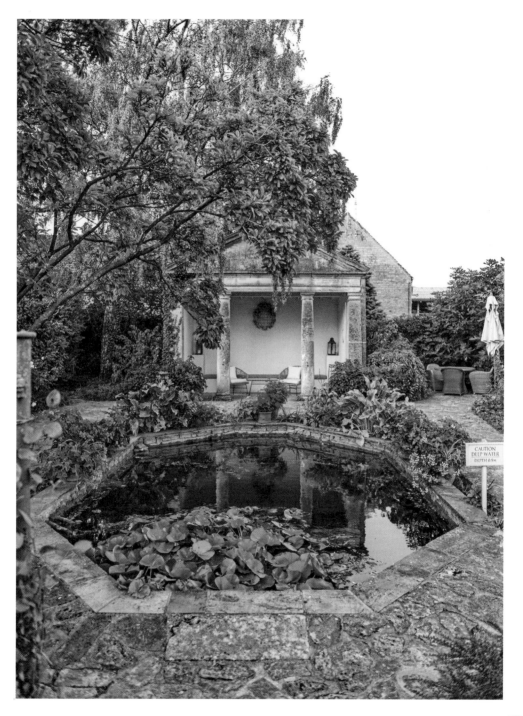

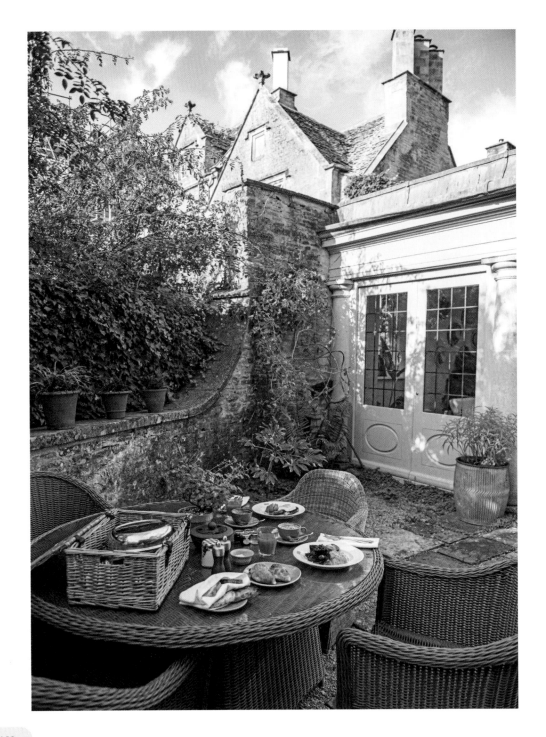

work there will happily chat to you about their techniques and give you handy tips for growing your own produce. So, if you bump into one, don't be shy! You will walk away more knowledgeable and inspired and maybe – like us – with some seeds of your favourite fruit or vegetable.

Has wandering through the gardens gotten you craving fresh fruit and veg? Great, because The Potager – which overlooks the gardens – has a garden-to-plate philosophy, serving vegetables, salads and herbs freshly picked that morning. Eggs are fresh from the chicken coop, honey from the hives and most ingredients are sourced locally within the Cotswolds. For your lunch, or if you are staying more than one night, you can head across the road to the Village Pub, part of Barnsley House, for their legendary cheese soufflé.

The rest of Barnsley House is entirely inspired by the garden. There are 18 rooms full of artworks relating to nature, such as watering cans, flowerpots, chandeliers – and many more objects that reflect the natural surroundings. We stayed in the Rosemary Verey suite, which was very intimate and serene and featured a little private garden and beautiful touches reflecting the original owner. Another noteworthy room is the Secret Garden suite, particularly popular with couples seeking privacy, maybe after a dip in the outdoor hot tub or a couple's massage in the beautifully designed treatment rooms.

+ INSIDER TIP
〰〰〰〰〰

Barnsley House is located only five minutes away by car from one of the dreamiest villages in the Cotswolds, Bibury. If you are staying in this beautiful hotel, you must pay a visit to what William Morris considered 'The most beautiful village in England' and take a photo of the iconic Arlington Row, weavers' cottages made of local stone, next to the River Coln.

C
O
U
N
T
R
Y
S
I
D
E

The Cotswolds for Foodies

A CULINARY DELIGHT

 2h by car ⊙ 24 hours

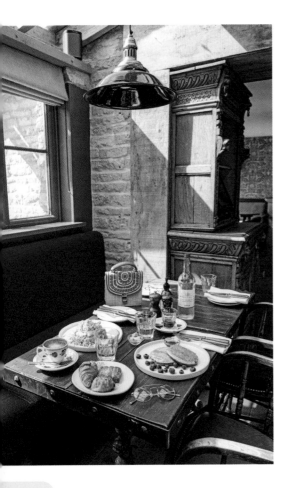

Ah, the Cotswolds! Time seems to have stopped long ago in these chocolate-box villages, and we find any excuse to leave London and head there for a weekend or even a day trip, as it's only a couple of hours drive away. The beautiful rolling hills and village charm aren't the only reasons that we love visiting this part of England. Indeed, the Cotswolds have become a real foodie destination, with restaurants serving typical local cuisine, sustainable food and the most beautiful afternoon teas. Many of these restaurants are set in countryside hotels, pubs and inns, which means that, as in London, you can experience and explore the place without having to actually stay there for the night. So, where should you go to make your trip to the Cotswolds extra special?

Many of the best restaurants are located in gastropubs and pubs with rooms, which have moved away from typical old-school pub food and gotten more creative with the dishes, adding a touch of fine dining without moving too much away from tradition – all with most of the ingredients sourced locally, an increasingly important consideration here for foodies.

The cosy restaurant at The Swan Inn is the perfect place to enjoy their delicious menu.

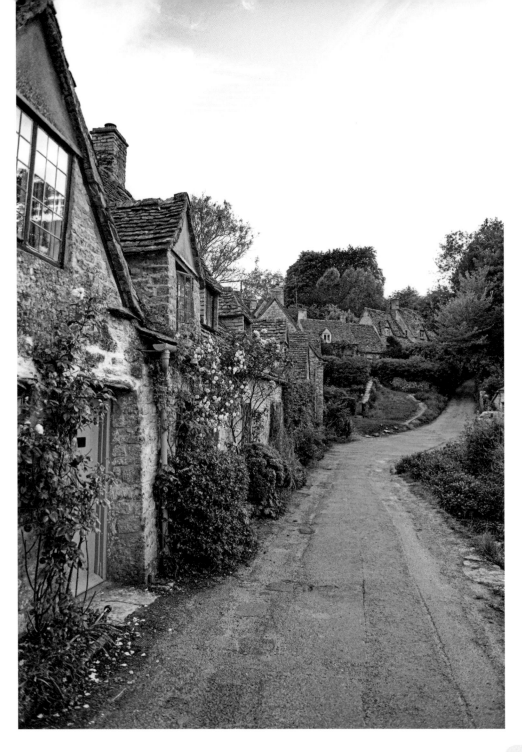

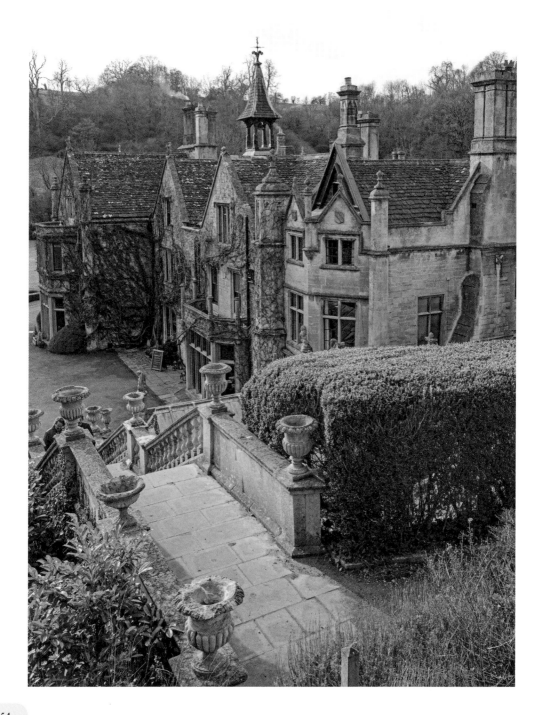

One of our favourites is the Double Red Duke, part of Country Creatures and located near Lechlade on Thames, where we often stop for lunch or dinner during the summer months, as it has beautiful outdoor seating, with the most Instagrammable red-striped umbrellas. The food here is simple but delicious, with chefs cooking over fire, and cocktails to die for.

Definitely try the scallops, the asparagus and the monkfish if you go, with warm chocolate cake and salted caramel ice cream as dessert. Also part of Country Creatures, and worth visiting, are The Swan Inn and The Chequers, both near Chipping Norton. The Swan Inn is a characterful sixteenth-century pub with a really pleasant ambience, which also has an outdoor space with garden grill nights in the summer and a cosy fireplace inside for colder days. The Chequers is everything a traditional pub should be, with its pretty stone exterior and cosy interiors. Here we have tried the best cheese soufflé yet, literally to die for, and one of the main reasons we keep going back. They also serve locally brewed beers if you happen to be in the area and fancy a pint.

Also in Chipping Norton is The Wild Rabbit, a gourmet gastropub and part of the famous Daylesford, the organic farm shop, deli and spa, which is just next door. Here the menu is seasonal and based on what is available at Daylesford, which is the best of the best when it comes to organic produce. It's very chic and one of the nicest dining experiences you will have in the Cotswolds – and well worth the slightly higher price tag given the quality of the food.

Also of impeccable quality and one that never disappoints is The Lamb Inn, in Crawley, a locals' favourite with an ambiance and decor that are just so relaxed and comfortable and a menu that changes almost monthly, with excellent homemade bruschetta and focaccia, together with a great cheese soufflé. Crawley isn't technically the Cotswolds (it's on the border) but it's definitely worth planning a stop here!

Another restaurant inside a pub that we love – and this one is a little secret – is the Feathered Nest Country Inn. The interiors are very quirky and every piece that you see is unique. The restaurant features a beautiful view over the Evenlode Valley and you can even sit outside during the summer. The menu is sustainably sourced and exquisite, with the tasting menu being a real journey for the palate. Also, did you know that the kitchen churns its own butter and bakes its own bread? If you decide to spend the night, they even have the cutest cottage where you can get cosy by the fire, which we absolutely love.

If you are heading to Broadway – and we would recommend going at Christmas time as it's absolutely magical – Russell's of Broadway

must be your choice for dining, especially if you are looking for something chic and special. It's set in a Cotswold stone house right in the centre of the village, so you really can't miss it. The food is excellent and creative, with everything being made from scratch in the kitchen and presented as a piece of art. It really is a dining experience you won't forget. The Village Pub, part of Barnsley House (see page 148–151), is also great and one of our favourites if you are visiting Bibury.

As mentioned before, gastropubs aren't the only option if you are looking for a nice dining experience in the Cotswolds. Hotels also have some pretty incredible restaurants, which often feature produce sourced locally or from their own backyard. That is the case for the Dormy House Hotel, near Broadway, which serves fine dining with a very creative touch in its restaurant The Garden Room, with the most indulgent passion fruit and chocolate soufflé as dessert. The hotel is set in a seventeenth-century farmhouse and is also wonderful if you decide to stay the night, with one of the best spas we have tried in the UK.

The restaurant at The Rectory Hotel, near Cirencester, also serves delicious food in a striking glasshouse, while the Thyme hotel (see pages 158–161) in its stunning Ox Barn serves seasonal

and farm-produced food sourced by the chefs and gardeners, who work together to select and grow the fruits, vegetables and herbs that are used to create the menu.

If instead you are looking for a quintessentially British afternoon tea, we would recommend heading to The Manor House in Castle Combe or to the Lygon Arms in Broadway. The Manor House is a stunning fourteenth-century luxury hotel located in one of the prettiest towns in the Cotswolds. You can just wander around the grounds and check out their stunning Italian gardens, but why not also stop for afternoon tea? The Lygon Arms is a historic inn that's been there since the fourteenth century, too. It was originally a coaching inn. The tearoom here is absolutely stunning and perfect for getting cosy if you are visiting Broadway for Christmas.

+ INSIDER TIP
〜〜〜〜〜

Planning the Cotswolds can be a bit tricky as there are over 100 stunning little villages, so we would recommend planning in advance and coordinating your foodie experiences based on which towns you are visiting, so that you are not spending too much time in the car, especially if you are doing a day trip.

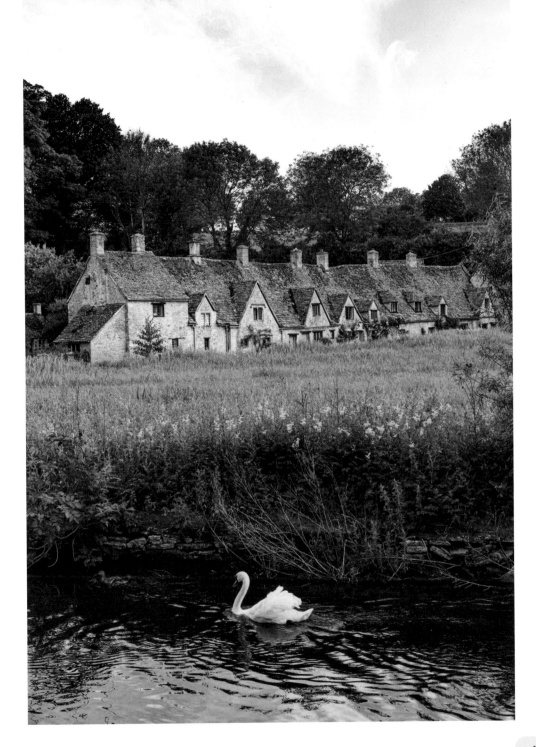

Thyme

A VILLAGE WITHIN A VILLAGE

🚗 2h by car 🕐 48 hours

Thyme is one of those places so special that you really have to visit to completely understand. Located in the quaint Cotswolds village of Southrop, it encapsulates seventeenth-century cottages, a 150-acre estate, a village pub, cookery school, a kitchen garden and spa. Still very much family-owned and managed, this perfectly restored Cotswolds manor and farmhouse makes for the perfect retreat away from London. Founder Caryn, eldest son Charlie and daughter Camilla make sure this peaceful countryside hamlet is of top-notch quality in every way.

Sustainability is a big thing at Thyme – and from the restaurant to the beauty products, it is making a big effort to respect nature and show its passionate love for its beautiful environment. Even the bedrooms, scattered between cottages and houses on the estate, are botanically inspired. Our favourite is the English Rose, in the Lodge, just a stone's throw away from the main house. As the name and the pictures might give away, this gorgeous sun-filled room is all pink, from the walls to the bed and the freestanding bathtub. We loved being able to wake up in the morning, open our windows and walk directly onto the lawn for our morning coffee, with a view of the fields beyond. Having the Meadow Spa within eyeshot, we decided to wake up, put our robes and slippers on

and head for a signature Bertioli massage, which included a mineral foot soak and a body, arms and scalp massage to release tension. Needless to say, we left feeling incredibly relaxed but to really complete our morning pamper we enjoyed a little swim in the calm outdoor and resident-only pool. Recent addition to the foodie spots is the Orchid House, located just alongside the pool, so great for a salad and ice cream but also bubbles and rosé.

As the sun is setting, follow the gravel pathway towards the Baa Bar and be welcomed by the iconic sheep seats or, if the weather is great, grab a seat outdoors and stay for a Myrtle Martini, made with herbs and fresh flowers from the garden. After you are done with your aperitif, head to the Ox Barn, the in-house restaurant. Everything on the menu is seasonal so the dishes change quite quickly according to what the chefs and the gardeners grow and forage from the garden. We suggest ordering a lot of dishes and sharing everything! The restaurant is so beautiful, with original beams, arches and walls, and it does have a romantic mood in the evening so it is a good excuse to dress up.

If you fancy more traditional countryside pub fare, head to the recently renovated and relaunched The Swan, just a short stroll from the main house, and still part of Thyme. Once known as the Bakehouse, serving bread and ale to the workers of the farm, now it is a firm local favourite and a little jewel in the countryside here, serving simple but refined English food. Finally, you can't miss Thyme's acclaimed cookery school! We absolutely loved our Middle Eastern 'cook and dine' class, but there are many others to choose from. Guided by one of Thyme's expert chefs, we loved learning about all the ingredients and techniques, and even picking our own herbs from the kitchen garden, but most of all eating our masterpieces in the garden!

+ INSIDER TIP

Leave space (a lot of space) in your luggage to bring home something from Thyme's own collection, Bertioli. From incredible soaps and beauty products to homeware, linens and interiors, all inspired by nature, we are sure you'll fall in love with every single product. Oh, and they have gorgeous silks too, all with Caryn's own botanical illustrations that take inspiration from the countryside around Thyme.

Cammas Hall Farm

PUMPKIN-PICKING FOR HALLOWEEN

 1h by car ⊕ 24 hours

Everyone seems to love autumn in the UK. Leaves slowly turn red and golden, making everything just so picturesque; temperatures drop, making for the perfect excuse to spend a cosy night in by the fire; and – most importantly – it marks the beginning of pumpkin season!

There is no better autumn activity than pumpkin-picking, especially with little ones. There are lots of pumpkin patches in the countryside, so it can be quite hard to choose where to pick the perfect one to carve for Halloween. We have visited quite a few, and although they are all well equipped and unique in their own way, our favourite is Cammas Hall Farm.

Located between Hertfordshire and Essex, this farm really goes all out in October, transforming its pumpkin patch into a Halloween spectacle. Think Halloween-themed mazes packed with witches, ghosts and ghouls, creepy crafts and a farm shop packed with goodies. We like saying that it's for the little ones, but I think it's actually us adults that enjoy it the most!

The farm is so beautiful that it even attracts photographers who go for full-on photoshoots with the spookiest outfits. In addition to this, there is a café that serves pumpkin everything, with the most Instagrammable pumpkin-spiced lattes and marshmallows.

So, when autumn comes, put on your wellies, head to Cammas Hall Farm, borrow a wheelbarrow and fill it up with everyone's favourite autumnal fruit (yep, it's not a vegetable!).

+ INSIDER TIP

Tickets go really fast, and when we say fast, we mean fast. Book as soon as possible so that you don't end up disappointed. Pumpkin-picking isn't the only activity that you can do at Cammas Hall Farm, so if you don't manage to go in October, go pick strawberries and gooseberries in late spring, or cherries, blackberries and blueberries in summer.

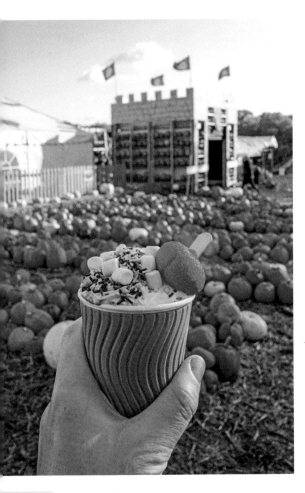

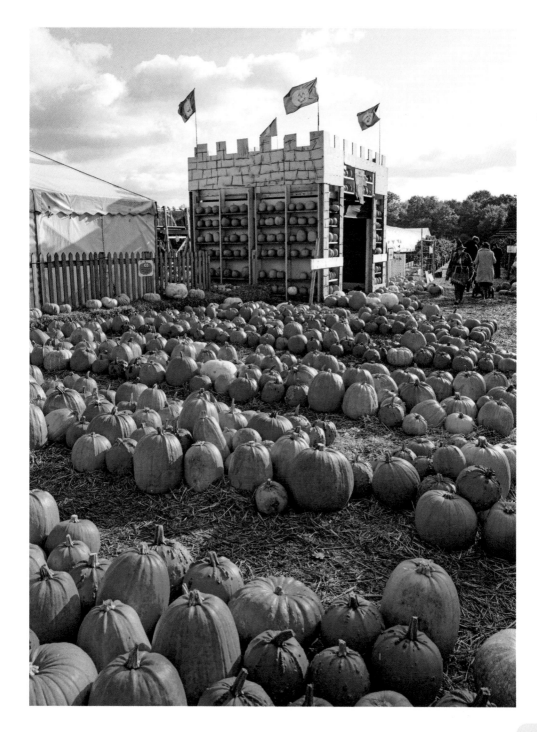

Cliveden House

🚗 1h by car 🕐 48 hours

With its rich history and glamour, Cliveden House is definitely one of our all-time favourite places to visit outside of London. Incredible interiors, gardens and an atmosphere that only a luxurious house with a palpable 350 years of history can have, it is the epitome of opulence. You will fall in love with it the second you enter through its grand iron gates.

Located in Berkshire, in 376 acres of stunning National Trust grounds, Cliveden House could tell many tales, if it could talk. Many powerful personalities, royals and politicians have walked the corridors – and more! – of Cliveden House, creating quite a few scandals too. Even the origins of the building are steeped in intrigue, as the 2nd Duke of Buckingham decided to build it, in 1666, as a gift for his mistress. Yes, we know, lucky her. . .

Since then, pretty much every monarch since George I has visited Cliveden House, as well as other luminaries such as Winston Churchill, Charlie Chaplin, President Roosevelt, Giuseppe Garibaldi and Meghan Markle, the Duchess of Sussex, who stayed there the night before her wedding to Prince Harry.

Of course, like any place with history, Cliveden has had more than its share of scandals, the most famous of which in recent times is probably the Profumo affair, which saw the Secretary of State for War, John Profumo, lay eyes on 19-year-old beauty Christine Keeler, the lover of a suspected Russian spy, by the outdoor pool. The married politician embarked on an affair with Keeler, the impact of which led to scandal, his resignation and his government being brought into disrepute . . . the rest is history (and a movie too).

If you want to stay over, every single room and suite is named after an illustrious past guest, and each room has its own unique charm, so you can have some fun taking your pick and reading all about its history. Our favourite room is probably the Sutherland – or as we call it, the 'pink room'. With a gorgeous pastel bed, worthy of a princess, a functioning marble fireplace and views overlooking the gardens, it is named after the Duke of Sutherland who purchased the house in 1849 as an occasional retreat away from London. We would say how lucky, but during the redecoration of the house, and only a few months into his residency with his wife, the house caught fire, causing the mansion to burn down. For the second time. Thankfully, Queen Victoria saw the smoke from Windsor Castle, only ten miles away, and being very good friends with the Sutherlands, immediately dispatched fire engines to help fight this terrible fire and contain the damage. Talk

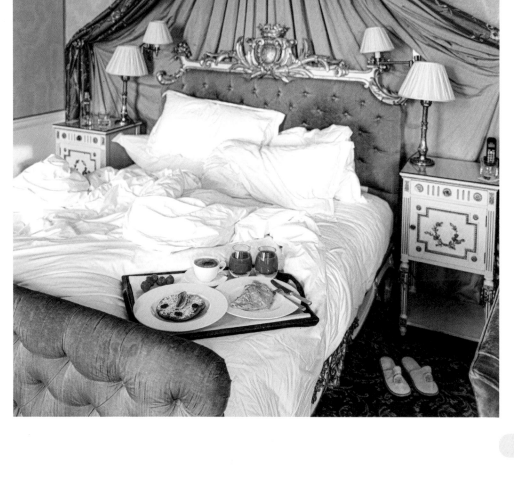

about having the right friends in the right places! The Duke then commissioned Charles Barry, the architect of the Houses of Parliament, to build what is the current house, managing to preserve much of the structure, shape and character of the original mansion.

Queen Victoria must have been very happy to be able to continue her visits to Cliveden House, travelling by boat directly from Windsor and stopping for tea at the secluded Spring Cottage. We can definitely see why she loved this little tradition so much; the banks of the River Thames are truly beautiful, especially in autumn when the leaves turn orange. This part of the river makes for a lovely walk from the main house, passing by the formal gardens down a little pathway. You can also rent a vintage boat to take you on a trip along the Cliveden Reach, with champagne and an afternoon tea picnic, if you want to go all out.

Dinner is an elegant matter at Cliveden House. Served in the Dining Room, which once was the Drawing Room, there are tasting menus based on fresh English ingredients and seasonality. The wine list is excellent and the staff are friendly and unstuffy and will make you feel like royalty.

While you enjoy your stay at Cliveden House you must pop by the spa and the relaxing indoor pool. The 'Profumo' pool is in the secluded garden, and is now the last remaining listed oudoor pool in the UK.

If you are wondering which season is best to visit, we love autumn for all the colours and misty mornings or summer to enjoy all that the outdoors have to offer. Our favourite has to be Christmas time however, when Cliveden House pulls out all the stops with magical decorations, festive afternoon teas and decorated rooms.

+ INSIDER TIP
〰〰〰〰

You don't have to stay overnight if you want to breathe in a bit of Cliveden's magic. The Grade I-listed gardens are part of the National Trust, so you can book a ticket for £16 and visit the topiary, floral display, see all the historical sculptures and have a little peek at Cliveden House.

Castle Farm

ENJOY THE LAVENDER FIELDS OF KENT

🚗 1h by car ⊕ 24 hours

One of our most loved day trips from London during the summer is to a lavender farm. The sight of these beautiful purple flowers just makes our hearts happy and it's the perfect way to destress from the city.

Castle Farm, near Shoreham, in Kent, is possibly our favourite, and with 130 acres of lavender it is also the biggest farm in the UK. Founded in 1892 when James Alexander brought down 17 milking cows from Ayrshire, Scotland, on a train, to this day the farm is still very much family-owned, and they grow fruit, vegetables, pumpkins and – of course – lavender. The latter was actually introduced to the farm quite a while ago, in 1998, with the purpose of being used for essential oils. Talking of which, make sure to buy some: they are made from pure lavender oil, within 20 minutes of being cropped, in an on-site distillery. So special! Another little treasure is their lavender honey, but you'll want to spend every penny at their shop, it's so tempting.

Now, time to run in the miles and miles of purple lavender! Don't forget to take pictures, of course, as this purple flower is highly photogenic and makes for the perfect backdrop. No wonder so many fashion magazines love to shoot here.

To visit during lavender season, pre-booked tickets are mandatory, but don't go on sale on their website until late June as the flowering season is very much warm-weather dependent. You have the option to book three types of tickets: a 45-minute self-guided access, an hour behind-the-scene access with a guide, and a two-hour bring-your-own picnic. Tickets, at the time of writing, vary between £4 and £12, so you won't feel too guilty about everything you'll later buy at the shop!

+ INSIDER TIP
〰〰〰〰

If you are looking to take some great pictures, head there at sunset when the light is at its best and opt for the picnic option so you'll have more time to shoot and have your own little set-up in the scene!

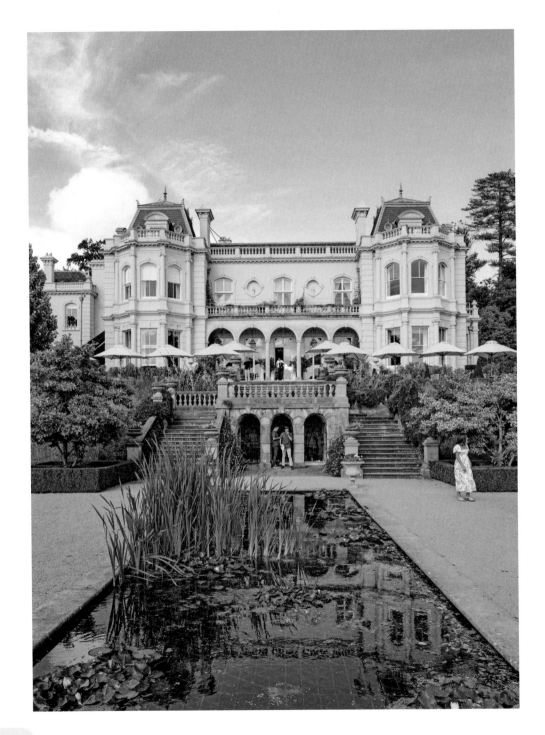

Beaverbrook Country Estate

MODERN GLAMOUR IN THE SURREY HILLS

🚗 1h by car 🕐 36 hours

The Beaverbrook Estate is set peacefully in the lush Surrey Hills, just a short drive away from Box Hill (see pages 174–177). It is enveloped in an area of Outstanding Natural Beauty, so imagine rolling hills, picturesque landscapes and a lot of greenery – and it's around an hour from London by train or car. Originally owned by Lord Beaverbrook, influential politician and media mogul, the house was the site of many a celebrity and political gathering. Past guests, such as Elizabeth Taylor, Ian Fleming and Beaverbrook's friend Winston Churchill, made their mark on this now Grade II-listed building, inspiring rooms and decor and imbuing the estate with the romance and style for which it continues to be famous.

Now a luxury country house hotel, Beaverbrook is a beautiful destination. Soho House designer Susie Atkinson helped design the interiors, the Japanese restaurant is run by a former Nobu chef, and the outstanding art in the house has been carefully curated. The in-house cinema is a restored Art Deco jewel and you can rent it out and connect your Netflix, while snacking on popcorn.

The spa has colour-drenched stained-glass ceilings and tiles. If the steam rooms, saunas, tailored massages and honey facials are not enough, there's also an indoor pool and summery outdoor pool – reminiscent of Gatsby.

No doubt hungry after so much pampering, you are in for a treat – food is a big thing at Beaverbrook. Both the Japanese Grill and at The Garden House, the Mediterranean-inspired restaurant, are excellent. The Omakase menu, in the former, allows you to try all of the chef's favourite dishes.

After dinner, a stop at Sir Frank's Bar is a must. Named after Sir Frank Lowe, Beaverbrook's creative director, responsible for the house's original design aesthetic, the Art Deco bar is gorgeous and features hundreds of works by influential Victorian botanical artist Marianne North (whose work you can see in North's gallery in Kew Gardens). From flower-adorned walls to the signature Spitfire Collins, the bar is one of our favourite spots in the house. So, get ready to dress down, or up, to fully enjoy all that this wonderful place has to offer!

+ INSIDER TIP

If you visit during the summer, don't miss out on the hot air balloon dining! Several stationary balloons, each seating up to four, are usually set in the Italian gardens. Don't worry, they don't actually go up into the sky!

Box Hill

 45m from London Vauxhall ⏱ 12 hours

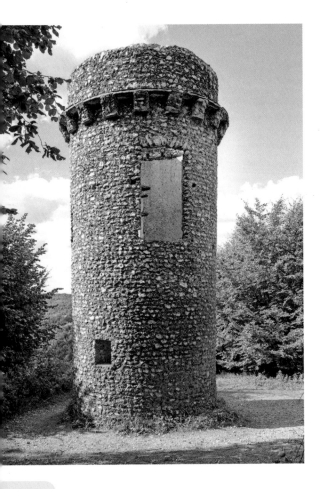

Sometimes, after a long week of meetings and photoshoots, we just feel like we want to hop on the first train and head somewhere to switch off and forget about London's noisy streets, while breathing in some fresh air, surrounded by nature (like most Londoners, we're sure!). Fortunately for us, there is a beautiful area of England only 45 minutes away by train, where we can do just that.

Box Hill is one of the best places you can go near London for a country walk, inspiring views and, if you want it, a more challenging hike. It's within the Surrey Hills Area of Outstanding Natural Beauty, one of 38 nationally protected landscapes in England, and it has many circular hiking trails, which means that whether you are a seasoned hiker or a casual stroller, there will be a route that is perfect for you.

There are trails that are 30 minutes long that will still take you to beautiful views and picnic spots, while there are longer ones that will keep you busy for at least a couple of hours. For the full range of options, head to the National Trust's website where you can find

The King
William IV

Mickleham

③ Running Horses

Whitehall
car park

②

①

Broadwood's Tower

BOX
HILL

④

⑤

Westhumble

Dorking

details and maps. We really wanted to go for the 'big one', so we decided to undertake the Box Hill Hike, eight miles of trail that takes approximately five hours to complete. The hike has different starting points, but we would recommend going to Dorking Station, if you are travelling by train, or Mickleham, if you are heading to Box Hill by car, as it has lots of on-street parking. This challenging route is full of steep climbs, descents and lots of steps, but you will be rewarded by incredible views and lots of fresh, clean air. Keep your eyes open for Broadwood's Tower [1], built in 1815 as a folly, and be sure to visit Mickleham's tenth-century church [2] and listed buildings.

We know from personal experience that this hike is tiring, so you will be happy to hear that there are many pubs on the way where you can stop for a refreshing drink or for some well-deserved food. You can head to The King William IV [3] for lunch, with some of the finest views in Surrey, or to The Running Horses [4] for a mid-hike Sunday roast and a pint. Only one though, there are plenty of valleys and hills to climb as you continue along the route!

Once you arrive at Dukes Meadow [5], cross the stile and stroll along the path running through the grassland. Take a moment to enjoy the peaceful scenery around you before continuing on to your starting point.

And if you want to extend your stay, head to nearby Beaverbrook (see pages 170–173).

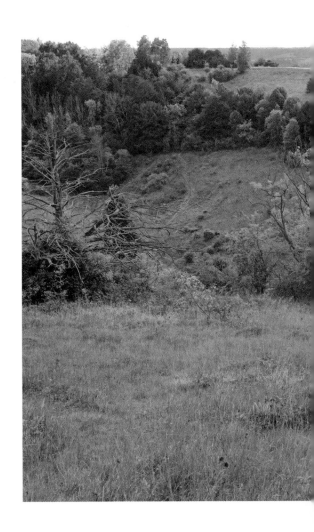

+ INSIDER TIP

Beat the crowds: if you are heading to Box Hill at the weekend, as it can get very busy, especially during the summer months. Also, don't forget hiking boots and hiking poles if you struggle with steps as some spots can be really steep.

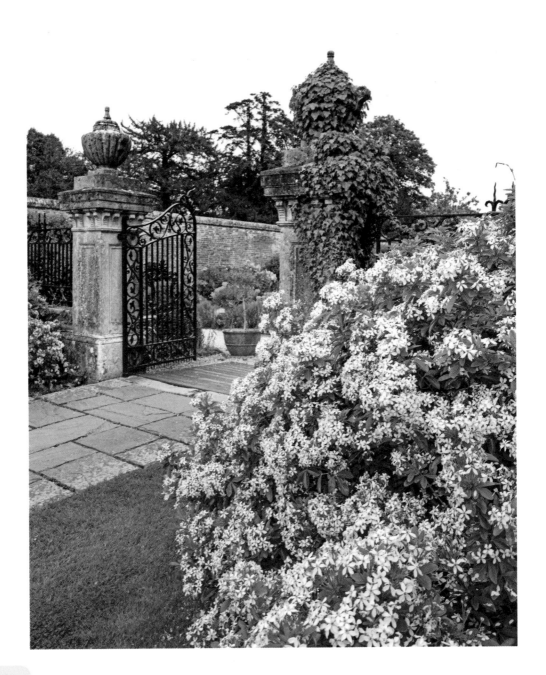

Four Seasons Hotel Hampshire

🚗 1h by car 🕐 48 hours

Nothing is more quintessentially British than horseback riding in the countryside, and if you dream about a place where you can wake up and mount a horse for a picturesque morning stroll, we might have found the perfect spot for you. The stunning Four Seasons Hotel Hampshire is set in a restored eighteenth-century Georgian manor and boasts 500 acres of land to really satisfy your cravings for a true countryside escape. If you are into history, you'll be pleased to know that the estate of Dogmersfield Park goes back a thousand years and the grounds are said to be where Henry VIII met his first wife, Catherine of Aragon.

This hotel is conveniently nestled only a one-hour drive from London and 30 minutes from Heathrow Airport, making it the perfect weekend away from the city.

From the impeccable yet cosy interior of the hotel to its beautiful surroundings, we found it ideal not just for couples who want to escape the hustle and bustle, but also for families with kids, given the many on-site activities to keep everyone entertained. Our recommendation is to wake up and get pleasantly lost in the rolling hills of this Hampshire estate after breakfast,

Opposite: Explore the impecable walled gardens.

for a morning walk in one of the most beautiful counties in England.

We also loved a romantic wander in the lush English gardens, breathing in the air filled with the scent of flowers and spotting the sixteenth-century original dovecotes by the Walled Garden, which used to host doves back when the hotel was a residential manor – and were a determination of the wealth of the owners.

But our favourite activity of all has to be the residential Equestrian Centre. There's nothing more unique than having your own private stables in your hotel grounds, right? It doesn't matter if you are an experienced rider and fancy a gallop through the sweeping lawns, or a beginner looking for a gentle ride by the lake and the canals to take it all in, you are in for a treat. The stables have more than 12 horses and even some miniature ponies for the little ones to stroke.

There are other fun activities, many of which are family-friendly too, encompassing British traditions and the spirit of the countryside, from clay pigeon shooting and tennis to a relaxing croquet match in the heritage listed gardens.

If you are more the laidback type, we totally recommend heading to the beautiful spa, a converted eighteenth-century stable, to be pampered with a signature aromatic-inspired

COUNTRYSIDE

Hampshire Herbal Massage, or a sunset swim in the gorgeous infinity pool.

As we are sure all this horse riding and exploring will leave you hungry, you'll be pleased to know that the on-site restaurant, Wild Carrot, has an incredible menu of locally sourced products from Hampshire markets, with a few Mediterranean delicacies, too. We totally recommend sipping on a seasonal cocktail at the bar before starting your dinner!

+ INSIDER TIP
〰〰〰〰〰

Highclere Castle, about 35 minutes by car, is a stunning estate that you might recognise as the main location for Downton Abbey. The hotel can organize private tours of the castle, in a chauffeured vintage Rolls-Royce. Also very close, only 25 minutes by car, is Jane Austen's House Museum, where the famous writer used to live and write her poems. She used to visit the manor at Dogmersfield Park (now the hotel), so you can really feel like you are retracing her steps.

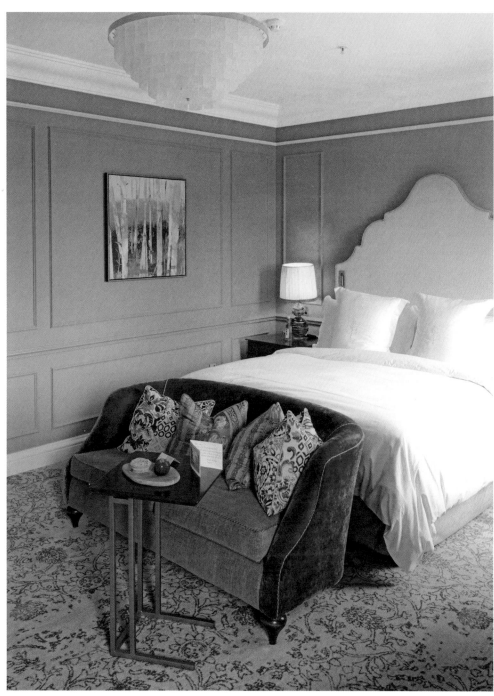

The sumptuous rooms are ideal for a romantic, weekend getaway.

Bombay Sapphire Distillery

A GINTASTIC DAY OUT

🚌 2h by car 🕐 12 hours

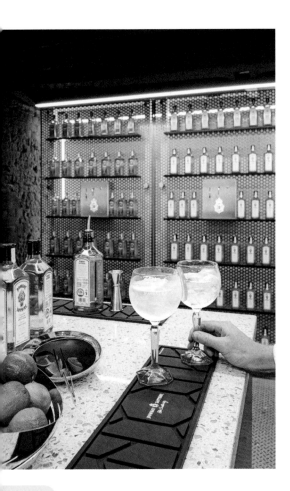

Gin is the most popular spirit in England right now. Who hasn't had a G&T on a warm summer day or during a night out with friends? Right now, there are some 820 gin distilleries in England and gin's popularity keeps growing year after year. Amazing when you think it was once considered evil and 'mothers' ruin'. But times have changed and most gins feature pure botanical ingredients – so, for a lovely day out, why not visit one of the most impressive distilleries in the country to see how this famous spirit is made?

The Bombay Sapphire Distillery is based on the site of a former paper mill in Hampshire. For over 225 years the Georgian and Victorian buildings produced the banknote paper for the Bank of England and the British Empire. Today they house a state-of-the-art sustainable distillery perfect for a fun day out with friends or co-workers.

The tour is outstanding and takes you through the production of this famous gin, with very knowledgeable guides who have the answer to any question to hand. You start by making your own gin and tonic from the self-serve machines, then you will discover the ten exotic botanicals infused to produce every single drop of Bombay Sapphire, and the secrets behind the Vapour Infusion process that gives this gin its bright and fresh flavour.

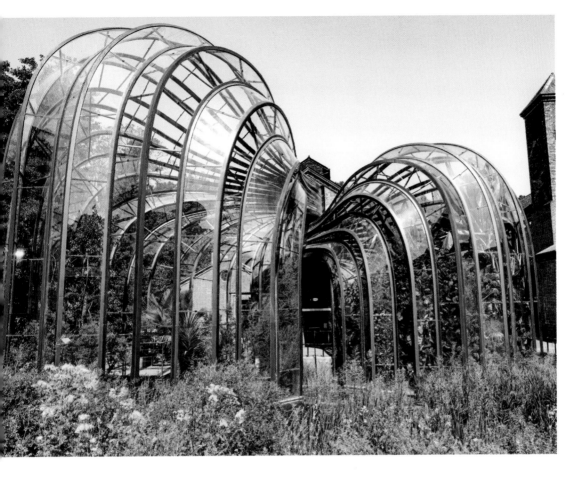

After the tour, go for a creative cocktail masterclass where you will taste different gins, vermouths and ingredients, together with nibbles, and create your very own cocktail recipe with the bartender's help. That is then bottled for you to take home and enjoy. You can also have some of your cocktails on the terrace by the river during the summer months.

If you want to take something special home, there are also limited-edition bottles to be purchased and personalised at the shop to make your friends jealous!

+ INSIDER TIP

If you fancy going for a walk before heading to the distillery, there is a beautiful 90-minute circular walk called Mill Trail that you can start and finish from the parking lot. We would recommend doing it before the experience as if you do it after we can't guarantee you will find your way back to the starting point, if you know what we mean!

Shere

LIKE BEING ON A MOVIE SET

 1h 30m by car 🕐 12 hours

Shere is the most photographed town in Surrey, and once you enter this quintessentially English village you can definitely see why. Think historic stone cottages, cobbled streets and cosy pubs, all surrounded by stunning scenery and beautiful sights. If this is not enough to get you to jump in your car and make this 90-minute drive from London, then maybe knowing that over a whopping 40 films have been shot in the village will do the trick!

We discovered this town while watching Christmas movie favourite *The Holiday*, where Cameron Diaz and Jude Law enjoy dinner at The White Horse, a pub in the centre of this little village. The pub was obviously our first stop, especially because we were feeling hungry after our drive (the perfect distance for a day trip). The White Horse is everything you would expect from a British pub, with lovely, kind staff and a very welcoming ambiance. It didn't come across as a garish tourist trap, with just a few references to *The Holiday* to please the movie fans, but that won't really affect your experience if you don't really care about it. If, after a stop at the pub, you fancy looking for the famous cottage from the film, you will most likely be disappointed as it was built specifically, so doesn't actually exist! However, you will be able to wander through the

streets where *Bridget Jones's Diary*, *The Wedding Date* and *Bridget Jones: The Edge of Reason* were filmed, making you feel as if you were on a Hollywood set.

In addition to being the perfect movie backdrop, Shere is also worth visiting for its beautiful walking and hiking trails, that take you through the stunning natural scenery surrounding the village. So, if you are heading there on a sunny day, do remember to bring your hiking boots, as you will likely need them.

+ INSIDER TIP
〰〰〰〰〰

It's probably best to visit this chocolate-box village during the week as it's relatively quiet; it can get really busy – like most places popular with tourists – during the weekend. It's also worth choosing a sunny day as you can guarantee you will want to walk through the beautiful trails.

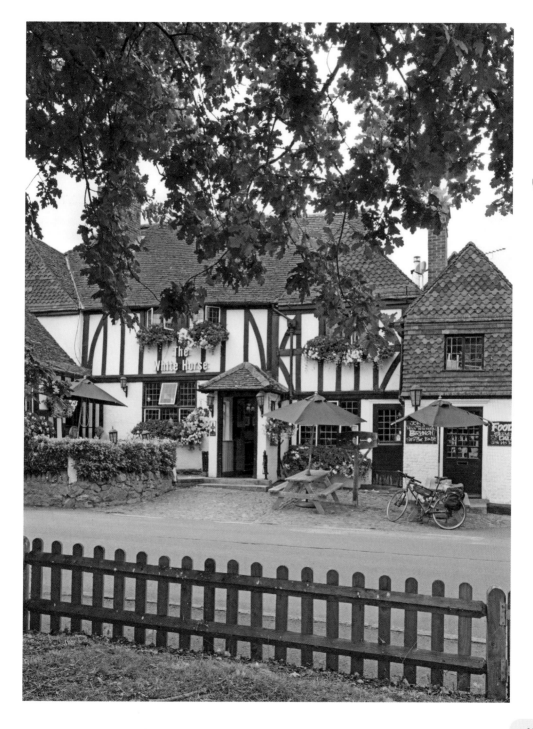

Leeds Castle

THE LOVELIEST CASTLE
IN THE WORLD

🚗 1h by car

🕐 12 hours

Leeds Castle has been called by many the loveliest castle in the world, and if you have been to this historical location in Kent, you can probably tell why. Its position on two islands in the lake formed by the River Len makes it just so picturesque, while its fascinating history, together with the many activities that can be done on the premises, make it one of the best day trips from London, especially if you are looking for a great family day out.

The castle is situated in the small village of Leeds in Kent, not to be confused with Leeds in Yorkshire. We have heard of many people who have missed weddings, shows and hotel bookings because of that confusion, so definitely something to remember! A castle already existed on the site in 857; it became King Edward I's residence in the thirteenth century and Henry VIII's house for his first wife, Catherine of Aragon, in the fifteenth century. The castle we see today mostly dates from the nineteenth century though, and has been open to the public since 1976.

A great place for a family day trip, kids can watch falconry displays, play in the maze, watch children's theatre and explore the underground grotto, while adults can enjoy some golf, classical concerts and the open-air cinema, in addition to sipping some wine in the vineyards. The tickets last for a year, so be sure to come back for some Christmas magic as the lights during the festive period are just stunning.

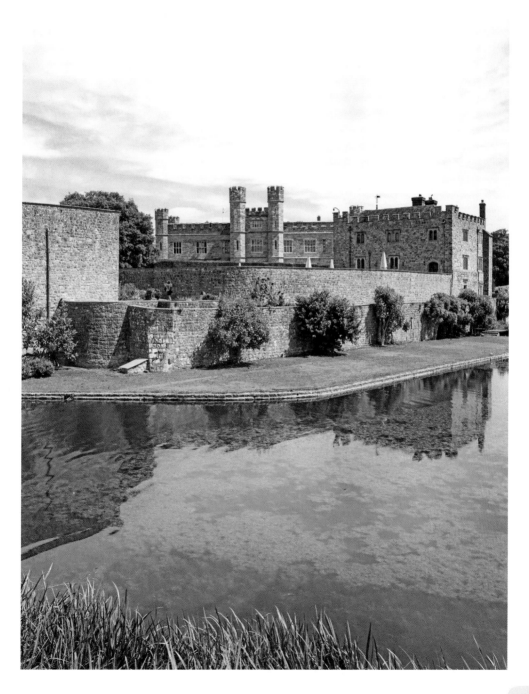

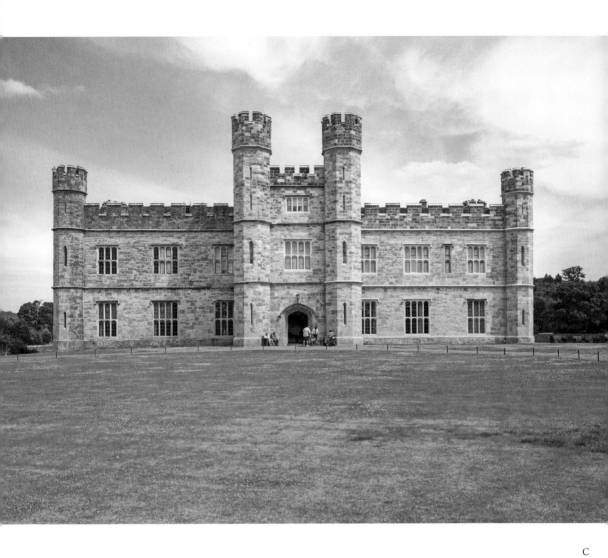

+ MAKE THE STAY LONGER

Want to feel like 'the King and Queen of the Castle'? Leeds Castle is also a fantastic location for a romantic weekend, as there are rooms and cottages where you can spend the night and enjoy the castle, grounds and restaurant once the gates have closed to visitors.

The Newt

A GARDEN ESCAPE

 2h 45m by car 🕐 48 hours

It's difficult to explain what The Newt is if you haven't been. Definitely more than a countryside hotel, this Somerset estate is a working farm, a cider producer, a shop and a garden escape.

It took six years to renovate and extend this 1687 Palladian estate and gardens, but we have to say, it was completely worth the wait. From the moment you enter the grounds, you can see that transparency is the ethos of this place and instead of the usual grand entrance, you arrive at the offices and it's core, to show this is still a working estate indeed.

The hotel entrance is situated in the beautiful Hadspen House, a Georgian limestone mansion, home to the Hobhouse family for more than two centuries. We love the classic style of the architecture and furniture, juxtaposed with some inventive and modern design. There are even paintings of some of the past residents of the house, and if you are curious to know more, the lovely staff can answer all the geeky questions you may have.

In terms of rooms, they are all quite different from one another, so you just have to see what appeals to you! The Hadspen rooms are all in or around the main house and near the spa and the gardens. The Stable Room, in the former stable, is one of the quirkiest, with original hay mangers

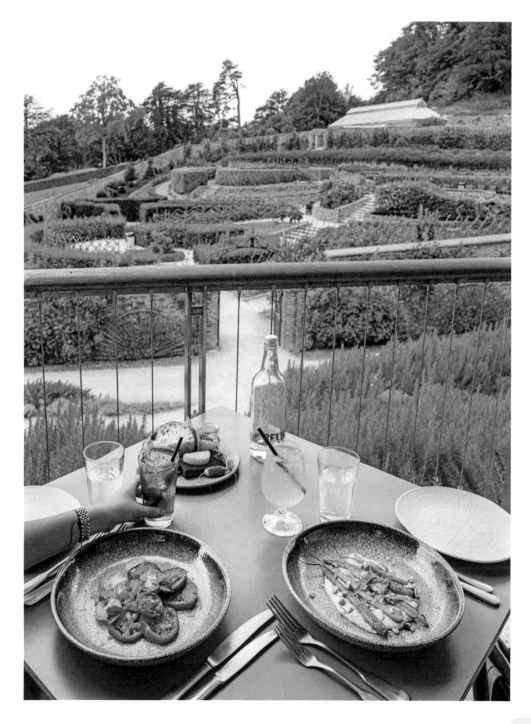

and tie-rings, and The Granary one of the most romantic and charming, built in the store grain for the animals, back in the day. The other rooms are situated about half a mile away, in the Farmyard, and are connected to the main room and spa with bikes and buggies.

In this former dairy farm, you'll find grazing cows, a pool, a bar and a restaurant, and it is really a great place to relax and disconnect. If you are into wellness, or just relaxation, you'll love the spa. The indoor–outdoor pool is truly beautiful and the exposed beams are a work of art. If you are a bit more active, you must check out the yoga studio and the gym, and you can even watch the chefs pick out herbs and veggies for your dinner while you are burning calories on the treadmill.

So explore the grounds, play croquet and make yourself at home! The pride and joy of this place are, without any doubt, the majestic gardens. To orientate yourself, the centre of the gardens is an egg-shaped parabola which is planted with a maze of all the apple varieties you can possibly find in Britain. From here, you can continue to the treetop walk in the so-called Viper, which takes you into the forest on a serpentine walkway about 40 feet above the ground. This is the best viewpoint from which to spot the resident deer! Head to the wild swimming ponds to spot the colony of the creatures that give this hotel its name bathing in the lake; they are native to these grounds. Lucky them!

In-between formal and working gardens, roaming chicks and ducks, oaks, pine and cedar trees and flowers, the gardens are an orchestra of beauty and functionality, and we bet you'll be as amazed by them as we were. On the grounds, you can also find a shop, a cider press, a mushroom house, an ice cream store and even a Roman Villa, rebuilt and imagined as a homage to a settlement and original foundations found on the estate and dating back to 351 CE. We recommend joining a tour or two – the cider one is delightful.

+ INSIDER TIP

What's so fantastic about The Newt is that they offer membership to the gardens so you don't have to be a hotel resident to immerse yourself in all this beauty. At the time of writing, it provides unlimited access for 12 months so you get to experience the ever-changing landscape and what The Newt has to offer in every season. You also get access to restaurants, workshops and seasonal events such as Harvest and Apple Day in autumn.

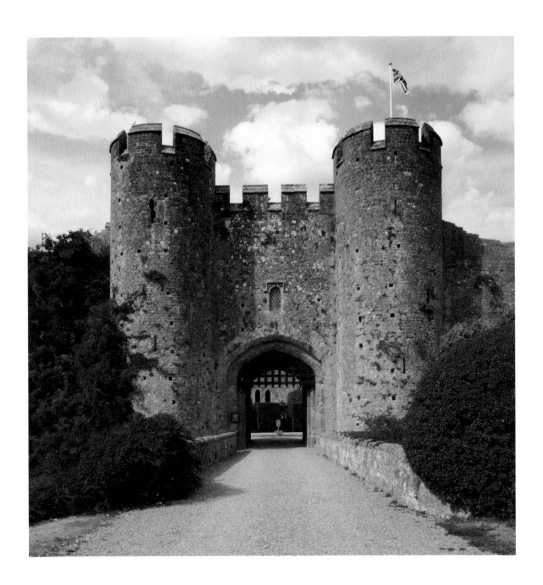

+ INSIDER TIP

*Take a leisurely walk in Amberley Wildbrooks Nature Reserve.
Particularly picturesque during winter, when the mist is coming over
the River Arun, this area is one of the richest wetlands in the UK and
home to rare birds, plants and other wildlife. You can start your walk
from Amberley village, accessing the reserve from Hog Lane.*

Amberley

A GEM IN WEST SUSSEX

🚊 1h 30m from London Victoria 🕐 12 hours

Amberley village is a quaint little gem – as the name alludes to – situated at the foot of the South Downs in West Sussex. Amberley is an elaboration of the word 'amber', the translucent orange gem that we all know and love. However, some people say that amber has its origins in old English and refers to a measure of volume, while the suffix 'ley' might refer to a field. So, the name could also come from the description of a local field – less romantic, we know. In any case, we think Amberley is a little jewel and deserves some spotlight!

The beauty and charm of this tiny village and the chocolate-box houses in every twist and turn will make you fall in love with traditional English villages. Direct trains run from the capital, making it a very easy day trip from London, and bringing you to one of the most romantic locations in Sussex in a heartbeat.

The first thing to swoon over are the picturesque thatched-roof cottages, often covered in wisteria and wildflowers; they make this village more than picture-perfect. And they'll make you want to have your own too. Of course, to see the cottages adorned with beautiful flowers, you'll have to visit in the late spring and early summer, but we think winter time is when the whole area gets truly magical. Imagine seeing all the cottages adorned with Christmas decorations, smoke coming out of the chimneys, truly out of a fairy-tale. But while its streets seem stuck in time (in the most beautiful way), Amberley Castle is very much alive and buzzing. Mentioned in the Doomsday Book, this impressive building is a popular wedding venue. It has an in-house fine-dining restaurant and you can even sleep in it! Amberley Castle is home to a luxurious hotel, and its décor and opulent surroundings allow you to dream of being the queen and king of the castle.

You don't have to stay there to explore the castle grounds, and we recommend stopping for afternoon tea or, if you're a foodie, the seven-course tasting menu. Then you can really experience the fragrant gardens, with their rose arches and topiary – you'll truly feel transported back in time.

Before leaving Amberley village, don't forget to stop at the cute Amberley Tea Room, for a cuppa, of course, and the most delicious homemade sponge cakes.

Five Best Pubs with Rooms

Here are five of our favourite pubs with rooms in the UK, all packed with charm, great atmosphere, but most importantly with comfy and stylish bedrooms and some of the best cuisine you will taste in the countryside.

1. THE SWAN INN *Ascott-Under-Wychwood*
This pub in Ascott-Under-Wychwood is set in a sixteenth-century, honey-hued stone building. The rooms are stylishly designed and the restaurant serves some of the best food in the Cotswolds, if not outside London. What we love the most, though, is the terrace with all its lovely nooks, the perfect spot to enjoy one of their botanical cocktails.

2. DOUBLE RED DUKE *Cotswolds*
The Double Red Duke is one of the most loved pubs with rooms in the Cotswolds, thanks to its stylish red-striped umbrellas, delicious award-winning food and quirky interiors. Ask for a room facing the garden and the greenhouse if you decide to stay here for the ultimate relaxing getaway.

3. THE BEAR INN *Hodnet*
Set in the historic village of Hodnet, in the Shropshire countryside, The Bear Inn has been a locals' pub for over 500 years. They did a complete renovation in 2021 and now it has 12 luxury bedrooms and serves food worthy of 2 AA rosettes. Given the history of this place, they say there is a resident ghost, so keep your eyes open!

4. THE DUNDAS ARMS *Kintbury*
This pub in Kintbury is nestled between the River Kennet and the Kennet and Avon Canal. Their crowning jewel is their garden which offers al fresco dining, showcasing locally sourced ingredients. A great spot for a summer getaway.

5. THE GUNTON ARMS *Cromer*
This historic pub is set in a 1,000-acre historic deer park in Cromer, north Norfolk. We love it for its cosiness and traditional British food. Think roaring fireplaces, candlelit dinners and quirky art pieces all around you.

Opposite: Enjoy a relaxing meal in the garden at the Double Red Duke.

The New Forest

A PARADISE FOR
OUTDOOR LOVERS

🚆 1h 30m from London Victoria

🕐 12 HOURS

+ INSIDER TIP

The New Forest is beautiful all year round, but our favourite season is autumn. The red and golden leaves make everything so picturesque, creating the perfect backdrop when taking photos of the deer and ponies.

The New Forest is one of England's few national parks and is spread across Hampshire, east Dorset and Wiltshire. It's easily reachable from London by train, so it always comes as a surprise when speaking to friends when we hear that they have never been. The New Forest is a paradise for outdoor lovers and there really is something for everyone, whether you want to hike, paddle board, go horse riding or go to the beach. We have been quite a few times and our favourite activity is walking along the forest trails in between the tall trees while spotting the many animals that the forest hosts. Much of the park has even been awarded the Special Area of Conservation status due to how rich in wildlife it is, so if you are an animal lover, this is definitely the day trip for you.

So, with an area that is so extensive, where is the best place to go if you want to spend a day in the New Forest? If it's your first time, we would recommend heading to Brockenhurst, as it's only 90 minutes from London by train. Brockenhurst is considered one of the best places to live in the UK, and you can tell why straight away. The atmosphere is so relaxed and quaint, and the town is packed with boutique shops, independent cafés and restaurants. Don't be surprised when you spot the village donkeys and ponies roaming free on the streets, and they may even come to say hello. How amazing is that?

The reason we chose Brockenhurst for your day trip is because of its many walking trails – and the one we would recommend is the Brockenhurst Village Walk. Starting from the train station, this five-mile walk is easily accessible and takes you through the village before leading you out and around the town. It's fairly straightforward and very picturesque, and you will see lots of ponies, cattle, donkeys and deer on the way, and may even spot a badger or two! Once you are back in town, be sure to treat yourself after completing the walk to a delicious cream tea at the Thatched Cottage Hotel, a Grade II-listed hotel, built in 1627, and located in the cutest cottage.

Alfriston

A POSTCARD-WORTHY VILLAGE IN EAST SUSSEX

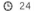 2h by car

🕐 24 hours

Have you ever seen a village so beautiful it should be on a postcard? That is exactly what you will think when you visit Alfriston, in the heart of East Sussex. Home to just over 800 people, this place, full of pretty pubs, medieval buildings and small shops, feels frozen in time. So what to visit?

We would recommend starting from Alfriston Clergy House. This lovely fourteenth-century Wealden house was the first place acquired, in 1896, by the National Trust. It has since been renovated several times but still maintains its rare chalk and sour milk floor. Today it is an idyllic, picturesque house, surrounded by a lovely garden, with views over the Cuckmere River.

Among the several well-preserved and historic buildings found in the village, there are some pretty intriguing inns, the most famous of which has to be the Star Inn. This hotel was originally a religious hostel, some 700 years ago, and was a stopover place for monks and pilgrims. It turned into an inn in the fifteenth century and was mainly used by smugglers. Today, you can stop and sit by a crackling fire and enjoy some typical English pub food, and stay overnight if you really fall in love with this village. It's pretty amazing that such historical houses are so well-preserved, right? Not something you see everywhere.

If you are looking to have some tea and delicious local scones, you can either head to Badgers Tea House or to our particular favourite, The Singing Kettle, both truly delightful.

+ INSIDER TIP

Wondering what's the best time to visit? Definitely summertime. And don't forget to bring your walking boots! While you can visit Alfriston in half a day, why not take advantage of one of the many circular walks around this gorgeous village? Head to Cuckmere Haven, along the Cuckmere River, for an exceptional view of the Seven Sisters cliffs, or towards the truly stunning Friston Forest.

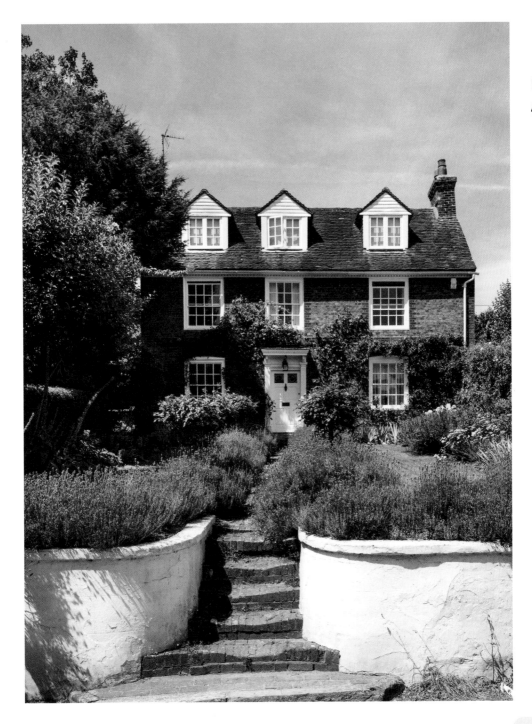

Chewton Glen

TREEHOUSE ROMANCE

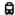 2h from London Waterloo 🕐 24 hours

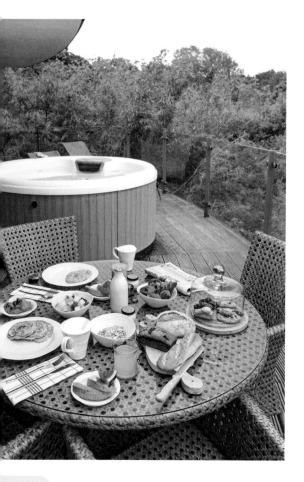

Remember as a kid, when you dreamt about having a cute little treehouse in your back garden to invite all your friends over and have sleepovers and adventures? Well, there are treehouses and treehouses, and what we are talking about in Chewton Glen, New Milton, in the New Forest (see pages 198–199) is the kind of luxury adults completely swoon over.

Set in the grounds of the much-loved elegant boutique hotel Chewton Glen, the 14 magnificent treehouses are what really makes this hotel stand out from the other five-star mansions in the UK countryside. Well, that, and also the impeccable yet thoughtful and caring service of all the staff, coupled with an intriguing county-club-like atmosphere – meant in the most unstuffy way possible, of course. Add to that the mix of gorgeous grounds complete with an outdoor heated pool, a relaxing spa and a unique location, and we bet you'll find it impossible to leave.

Chewton Glen is located on the edge of the lush New Forest, something you can clearly feel from the height of your treehouse, and it's

Each morning a hamper is delivered to your door so that you can enjoy breakfast with a view.

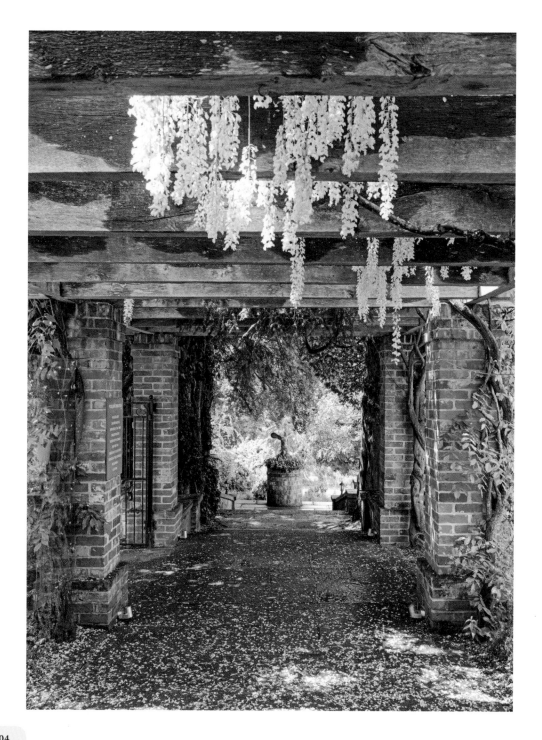

a ten-minute woodland stroll from the beach, so you definitely have the best of both worlds! We recommend following the stream that runs from the treehouses directly into the sea, passing by the golf course, and heading for the so-called 'Beach Walk' to reach the seaside for a picnic and some sea breeze (and sun, if you are lucky).

Once you are back in your treehouse – ours was called Elm – you'll feel like you are in another world completely, cocooned by nature in the sky. We stayed in the early summer, and we can guarantee you all the greenery in front of us made us feel like we were somewhere tropical. It must be magical throughout autumn too, when all the leaves are turning orange, so do send us pictures if you stay during that time – we'd love to see it!

A firm favourite of our stay was receiving the daily breakfast hamper, full of delicious goodies, juices and baked treats. It was delivered punctually to our room at the crack of dawn through a little passage so that we wouldn't wake up. We loved to get out of bed, make ourselves a cappuccino in our kitchenette, which comes with all manner of complimentary treats, grab the hamper and set up breakfast on our balcony, listening to the birds singing and watching squirrels running up and down the trees. Needless to say, some were very curious about our breakfast!

If we had to choose our most loved feature though, it was definitely the hot tub. Set in our wooden deck, it made the perfect spot to watch the sunset from – and with a glass of champagne in hand and gorgeous views we can't think of a spot more romantic.

For dinner call your personal concierge – yes, the treehouses do come with one – and enjoy being transported directly to the restaurant by buggy, resort style. You'll be in for a fabulous meal in the Dining Room, with a mix of typically English and cosmopolitan dishes to satisfy all your cravings. We recommend the grilled Dover Sole, one of the best we've ever had, and the signature twice-baked Emmental soufflé – so decadent.

Before you leave, stop in for afternoon tea and pair it with a glass of English sparkling wine, to make your departure a little sweeter. All in all, we can't recommend this place more for a romantic getaway and a special occasion; it's something you'll remember forever.

+ INSIDER TIP

There are also traditional rooms and suites at Chewton Glen, so you don't have to stay in the treehouses if you don't want to. The Croquet Lawn rooms are just gorgeous – so quintessentially British.

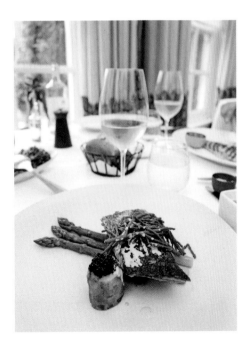

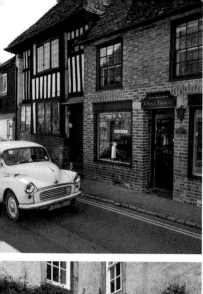
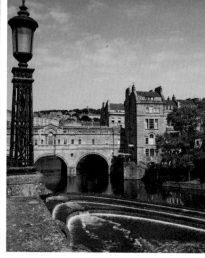

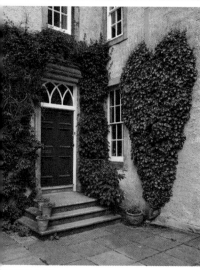
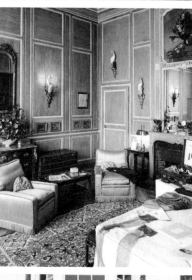

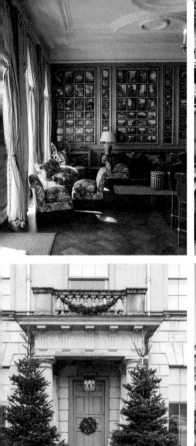
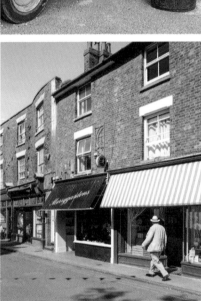

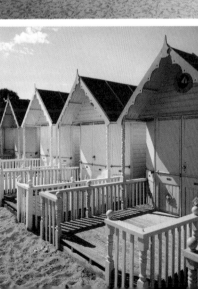

Acknowledgements

Imagining and writing this second book has been such a passion project for us, so thank you to everyone that made it possible. A special thank you to:

Our Followers – Thank you for following us along, without you @prettylittlelondon and this book wouldn't exist! Thank you for engaging with our content every day, for being curious and pushing us to discover new places. All the love for the first book made this second one possible.

Friends – Thank you for the support and the excitement! Sorry for disappearing for four months to put together this book, but we hope you love the result.

Family – Thank you to all our family and in particular our parents Antonio and Joy, Maria Paola and Gabriele and Nonna Ilva. Thank you for supporting us and always encouraging us to chase our dreams.

London's Content Creators – Thank you for the support with our first book, those shares and your enthusiasm were really important to us.

Publishing Team – Alice, Charlotte, Lewis and everyone at Quarto. Thank you so much for believing in us a second time. Your help has been once again so valuable and without you guys this book wouldn't be here!

A huge thank you to all the lovely hotels and restaurants around the UK who believed in this project and have offered to host us. You have been a huge help by accommodating us and we hope you like how the book turned out. Special thanks to Ale and Will, our Cotswolds guides and friends, who have shared with us all their little secrets of this beautiful area.

Finally, thank you to everyone who bought this book. We very much hope it will inspire you to explore this beautiful country and see that there is much more beyond London! And don't forget to take loads of pictures along the way…

First published in 2023 by Frances Lincoln Publishing
an imprint of The Quarto Group.
One Triptych Place, London, SE1 9SH
United Kingdom
T (0)20 7700 6700
www.Quarto.com

Text and photographs © 2023 Sara Santini & Andrea Di Filippo
Illustrations © 2023 Emma Block
© 2023 Quarto Publishing Plc

Every effort has been made to trace the copyright holders of material quoted in this book. If application is made in writing to the publisher, any omissions will be included in future editions.

A catalogue record for this book is available from the British Library.

ISBN 978-0-7112-8025-0
EBOOK ISBN 978-0-7112-8026-7

10 9 8 7 6 5 4 3 2 1

Design by Rachel Cross

Printed in China

FSC
www.fsc.org

MIX
Paper | Supporting
responsible forestry
FSC® C016973